ALIEN
HORIZONS
THE FANTASTIC ART OF BOB EGGLETON

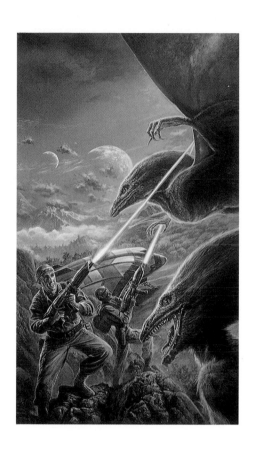

A L I E N
HORIZONS
THE FANTASTIC ART OF BOB EGGLETON

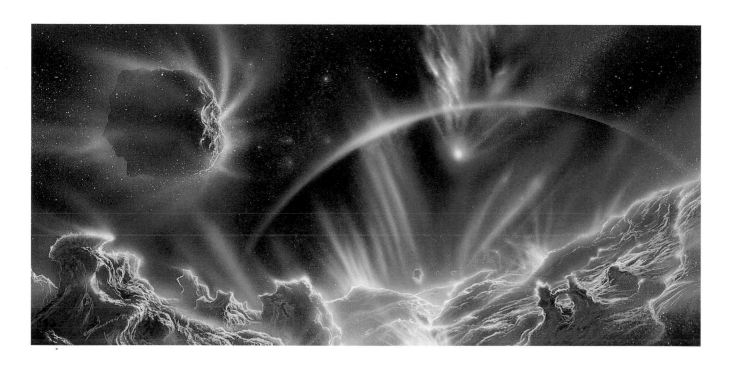

TEXT BY NIGEL SUCKLING
INTRODUCTION BY GREGORY BENFORD

Paper Tiger
An Imprint of Dragon's World
Dragon's World Ltd
Limpsfield
Surrey RH8 0DY
Great Britain

First Published by Dragon's World Ltd 1995

**The catalogue record for this book is available from
the British Library**
ISBN 1 85028 336 2 Limpback
ISBN 1 85028 337 0 Hardback

Editor: Fiona Courtenay-Thompson
Designer: Nigel Coath at ProCreative
Art Director: John Strange
Editorial Director: Pippa Rubinstein

Quality Printing and binding by
Kyodo Printing Company Limited,
Singapore

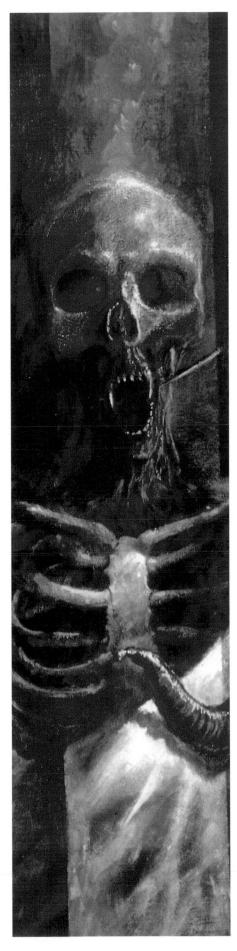

Contents

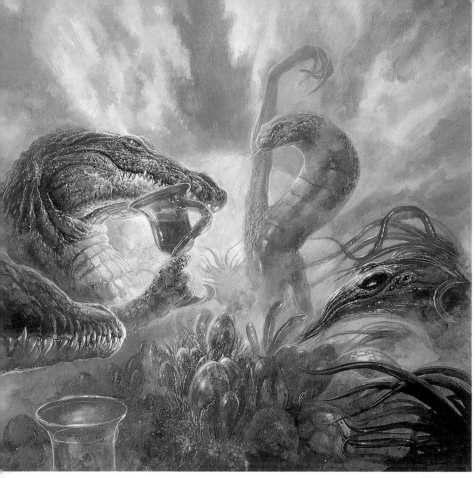

◀ *Trizark 1994*
Acrylic
13 x 13 in (33 x 33 cm)
Interior Illustration,
Science Fiction Age *magazine*

An alien wedding feast. By a quirk of intergalactic synchronicity, some of the revellers bear a strong resemblance to the colder-blooded branches of earth-life. To capture the frenzied mood a looser style was adopted than usual, without any airbrushing.

Freaks 1993 ▶
Acrylic
12 x 15 in (30 x 38 cm)
Interior Illustration,
Science Fiction Age *magazine*

For a very sad and soulful tale about a circus freak show. This poor creature is one of the exhibits, terrified of her gawping, mocking public and riddled with doubts about her whole existence. It turns out, though, that she is not just a hideous deformity. Her father was an alien and her present form is but a larval stage, a husk or shell from which she will emerge in an indescribably beautiful form. A poignant retelling of the *Ugly Duckling* story. From the scale of response Bob has had to this picture it touches a common chord.

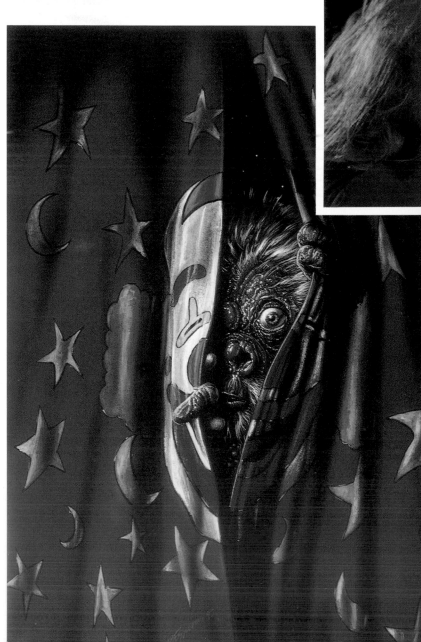

Introduction: A Lyrical Hardness

Between writers and artists strums a tension stretched by both envy and admiration. Bob Eggleton brings that out in me maybe more than any contemporary illustrator of the fantastic. Artists seem to have it so easy, in a single flash of vision they can show you the whole world.

Photo by Kristine Struminsky

For writers of realistic science fiction, artists who can get it right are essential in communicating our world view, the implicit promise in our prose.

Today, Bob Eggleton is quite possibly the leader in hard science fiction illustration. He renders alive, in searing colour, a huge red giant star being gravitationally stripped of its envelope by a hot, small star. It's easy to be gaudy, but as an astronomer I eye the piece and think, 'too blue to be a white dwarf, so probably it's an oddity – a neutron star? Maybe it's kindled into a virulent glow by that serpentine tongue of infalling mass – yes, that makes sense.' Every scientific nuance is there. The small star's brilliance we see in the furthest turn of spiralling matter, while the red giant's power reflects from the other side of the descending gyre.

In the 1940s, Chesley Bonestell began a long tradition of realistic, hard-edged visionaries of the unknown. Eggleton came into this school of fantastic illustration when the Bonestell approach, using oils in classic, laborious fashion, was giving way to the new materials – airbrush and acrylics. This did more than speed up production, it also vastly expanded the range of colour and tone available. Rather than stick with the underplayed tones of photorealism, Eggleton ranged through the spectrum. The effect of using this full scope of colour is sometimes startling. We forget that we evolved to see in an atmosphere which equates distance with blurring and shapes our habits. Astronomy tells us that many objects in airless splendour are vivid and sharp, with 'unrealistic' mixes of hues. At times, nature is peacock gaudy. This Eggleton understands and uses to produce solid, eye-fetching, commercial art.

Astronomers measure luminosities and spectra, but that does not mean we actually know how things look. To integrate the latest data into his work, Eggleton scours

journals and reads widely. This steady labour brings subtle and uncertain areas under his command.

The artist can simply show all the crisp details and enigmatic aspects, rendering up murky mysteries, shifted perspectives, dizzy surrealistic overlaps of the hard-edged and the fuzzy — all working together at the same instant of discovery.

Of course, close inspection reveals more; cunning details tucked in here, obscure jokes provoking a smile there. Just when you're settled into the view of Eggleton as an heir to Bonestell, here come iguanas and Nazis, a whiff of Eggleton having fun with a commercial assignment. Or his many dragons — sharp, exact, but still playful.

More than once I've picked up a book because it's cover made me want to follow that age-old lure — 'what's happening here?' — and discovered that it was an Eggleton. Cover artists learn the arts of enticement, or move on. Writers have it much differently. We are forced to come at you ponderously, serially, and at a pace dictated by your reading speed, your wandering attention. We must excite your fitful urge to do the mental labour that converts these squiggles on the page into intelligible thought.

Consider Eggleton's painting of starships manoeuvering, one spraying a blue fire forward at an earth-like planet, while beyond, the galactic plane seethes with orange energy toward the bulging core. Movement, drama, spectacle. To capture a fraction of the interest that single quick image conjures up, poor Greg Bear in *Anvil of Stars* had to labour mightily. Eggleton gives us that with a detailed vision, a lyrical hardness.

Anyone can browse the entire life's work of our best artists in an hour and emerge refreshed, stretched, informed and charmed. To catch up with even moderately productive writers takes weeks, maybe months of unstinting ploughing through thickets of words, words, words.

Of course, we writers do have our advantages. We can set up a pace, an energy and drive that make the term 'page-turner' mean something. We can run through the full range of suspense, humour, dash and colour, in our sprawling, roomy novels. Artists have to concentrate, to say much through implication that we can (literally) spell out.

Fortunately, artists have their one tight rectangle and must work their magic in that small compass. Such constraint imposes excellences we writers could well learn from in the era of fat trilogies.

I've always thought of Bob as fundamentally an astronomical painter with his certainty of dramatic effect and scrupulous attention to the latest astronomical information. I was happy to get Eggleton covers on two of my books, the exploration novels *Jupiter Project* and *Against Infinity*. He got the colours of Jupiter's atmospheric bands

◀ *Necroscope 3 1989*
Acrylic
13 x 25 in (33 x 64 cm)
Book cover, Tor Books
Author Brian Lumley

One of a set of improvisations on a human skull theme. Bob was a bit uneasy about blending it with an animal, as here, but everyone else seemed to like it.

and swirls exactly right, relying on NASA true colour photos, and shrugging off attempts by art editors to alter tints and hues.

God is in the details, a philosopher once said. The result was covers I could live with as a scientist and enjoy as a writer, for they conveyed the gritty, hard-edged feel I wanted to evoke in the novels themselves. To write about our solar system has always seemed to me a demanding task, requiring a firm knowledge of what looks technically plausible, yet knowing that further exploration may well prove you wrong.

Questions frame every painting. Could Jupiter's moon be colonized? Why would people go there? How could they survive? In Eggleton's carefully thought-out designs, we see the machines that could make that possible, a looming, icy beauty makes its own argument for going, seeing, staying.

There's more to him than that, of course, but you have to prowl the book stores to see it all, scanning the titles for that crisp, yet dramatic look that is his signature. He can grab you in that frozen instant when a painting makes its claim on you, draw you in, maybe even sell you the book on the strength of his vision.

Writers depend on artists to do that first, essential job for them. Ideally, one should be able to judge a book by its cover — or else what's it there for? So between writers and artists there is no intrinsic competition. We do different jobs for the reader.

Eggleton combines dash and detail — no easy task. He helps frame the view of our possible futures and destinies as much as any writer in the genre. He knows the field. Already Eggleton has produced a prodigious body of painting. At his half-century mark, deep in the next millennium, there will be whole, vast galleries to visit and ponder. Meanwhile, this book gives a first sampler, a genuine treat.

Gregory Benford, 16 May 1995

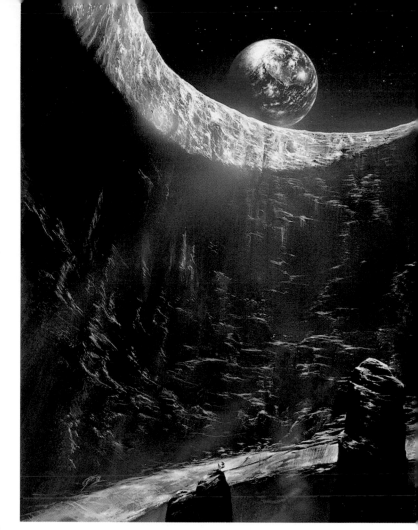

Into the Sunlight 1989 ▲
Acrylic
12 x 15 in (30 x 38 cm)
Interior Illustration, The First Men on the Moon, *Donning Books*
Author H.G. Wells

'I wanted to indicate the immense scale of Wells' 1899 vision of what lay in wait for visitors to the moon. Note the two humans at the bottom. Overall, the picture was greatly influenced by Frederick Church and Albert Bierstadt.'

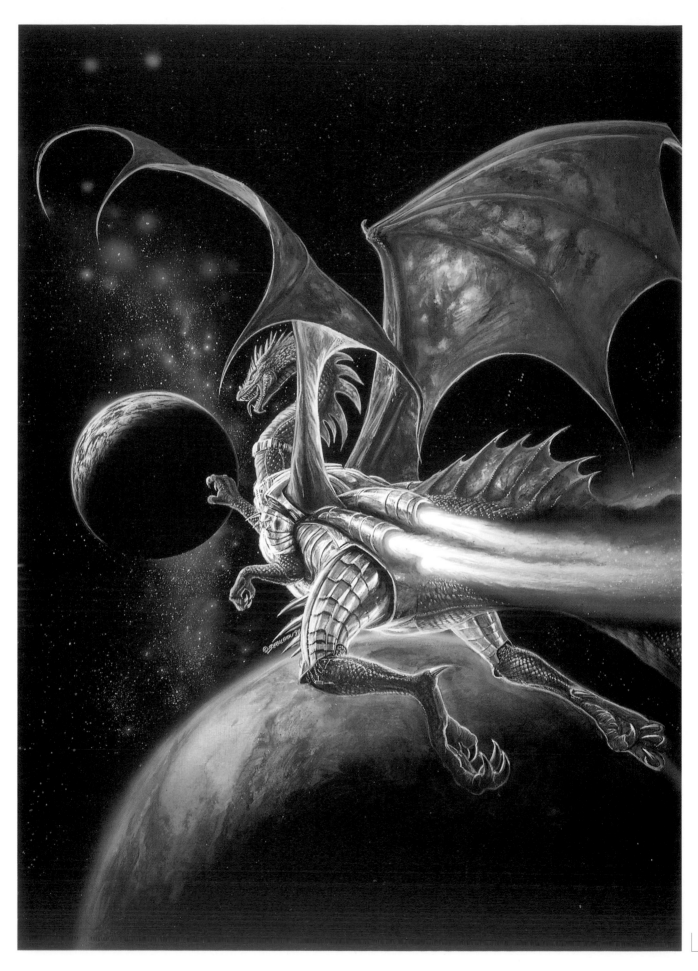

Fantasies

'**A**rt for me is not just a job,' says Bob Eggleton, 'It's my life. I just happen to make my living from it. Artists see visions that other people don't necessarily see. It's often hard for other people to understand this, particularly people you share your life with.

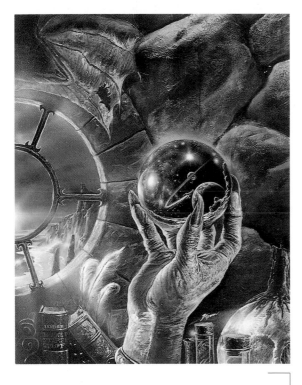

Crystal Ball 1989 ▲
Acrylic
17 x 20 in (44 x 51 cm)
Book cover, Dark Harvest Books
Author Fritz Lieber

To celebrate fifty years of the author's work ranging from fantasy to science fiction. Bob read a number of the stories and came up with this image combining the two strands. A back cover was also planned with a spaceman's hand holding a similar object, but containing a fantasy scene. In the event it was dropped but Bob still intends to paint it some day.

◀ *Astro Dragon 1994*
Acrylic & Gouache
17 x 25 in (43 x 64 cm)
Promotional poster,
North American Science
Fiction Conference 1995

Bob was asked to show elements of science fiction and fantasy combined in this image, providing him with a chance to indulge his love of Japanese monsters.

I work strange hours for a start. Sometimes at two thirty in the morning I'll wake with an idea and start sketching. Once an idea gets into your head you have to catch it, so I always carry a sketch book in case an idea comes along. It means I'm never at a loss for ideas, there are always some I'd like to finish as paintings, and sometimes they're just what a client wants.'

Bob is very happy with the niche he has found as a painter of the fantastic, an illustrator of dreams and nightmares. Book cover illustration has been especially satisfying, passionately so, and although he has branched out in other directions it remains the heart of his output. 'Whatever else happens I would always like to be doing book covers and staying in touch with people. You get fan mail from the most interesting places, and sometimes people point out things I haven't even noticed myself. There's a satisfaction in communicating like that without ever seeing or meeting the characters

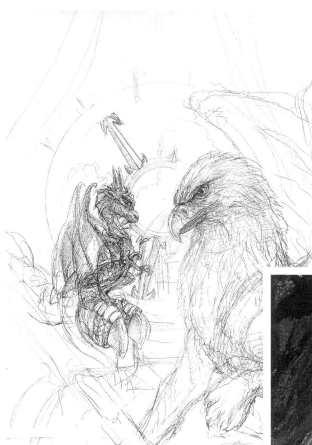

involved. I see no problem at all with the purely commercial side of my work. If someone comes and shows me exactly what they want, then I'll do it. Ultimately it helps both client and artist, it gets the work out there and seen. Of course a free hand is better and I'm often given that.'

The Wizard's Heir 1994 ▲
Initial Idea

'This is the rough version, my earliest thought processes coming together. The image is clear in my mind but I like to rough it out quickly with felt markers. I'd show this to an Art Director but not an editor. The story mentions a circular window, so I couldn't resist using it to draw the figures together.'

The Wizard's Heir 1994 ▶
Colour Brief

'I like to work loosely with colour roughs as I don't want to feel the final thing is just a repainting. Also the client may want changes so why do something detailed. The best roughs are the ones that only make sense when you squint.'

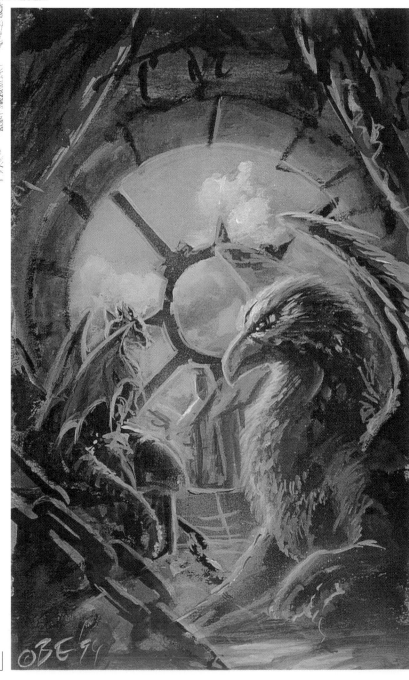

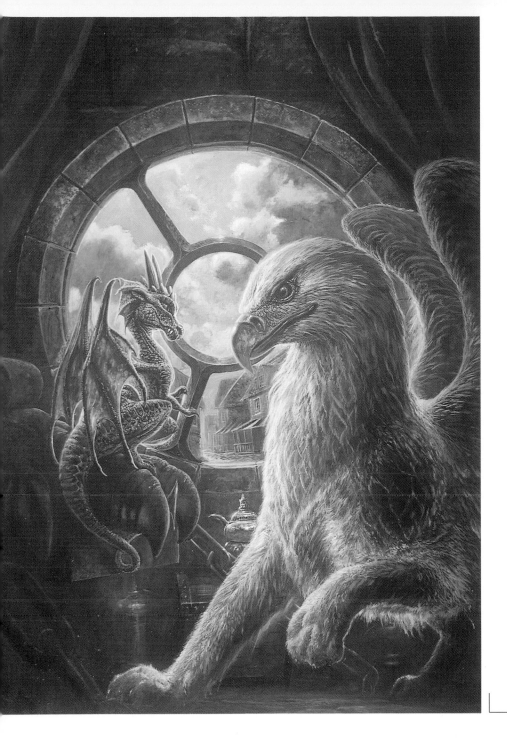

◄ *The Wizard's Heir 1994*
Acrylic
20 x 30 in (51 x 77 cm)
Book cover, Ace Books
Author Daniel Hood

'I loved painting the Griffin in this picture and wanted him to appear like a real live creature fully interacting with the small dragon. A while later I saw a cat taking just this pose and it was kind of reassuring to see I'd got it right. I didn't use any airbrushing and painted in acrylic but with a very classical method. Apart from the main figures I most enjoyed doing the clouds and lighting effects.'

When not given a completely free hand with a subject, Bob still generally has quite a big say in the matter. 'It took a long time to establish a reputation, but I seem to have developed an instinct for what will sell, which people trust. Usually covers start with the publisher throwing in an idea that I use as a springboard, taking it to extremes. If elements are not so good I'll urge the publisher to drop them, but usually I'll take their idea, even if I don't agree, and try to turn it around to make something interesting. Some fellow artists have

One advantage of a fairly detailed rough
is then being able to step back and weigh
up the overall composition. It gives a
second chance to get things right.

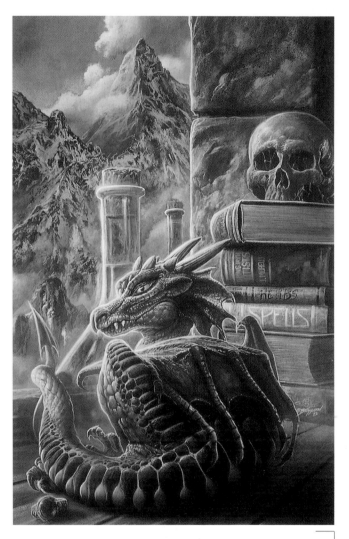

Fanuihl 1993 ▲
Acrylic
12 x 18 in (31 x 41 cm)
Book cover, Ace Books
Author Daniel Hood

The first of a pair of stories. The
publisher specifically didn't want a
'cute' dragon but something along the
lines of a moody cat. If you rubbed
this one's head he might be pleased,
or might rake your arm open. The
story tells of a magician who is
murdered. Here his pet dragon is
about to set out for revenge.

accused me of being too commercial but I'm
simply doing my job, helping publishers and
satisfying readers. I see nothing wrong in
taking fine art elements and making them
into a book cover. Ultimately it gives me a
real thrill.

'What I like to do is create an image that
will sell a book and tell the reader something
about it without giving too much away. I go
for events that happen just before the action.
Failing that I just try to create the right mood.'

Fantasy has always appealed to Bob, but he
has only quite recently had the chance to
exercise his talents in this direction, and then
only after a determined effort to break into
the genre, 'I've always been a huge fan of
writers like Edgar Rice Burroughs, and I really

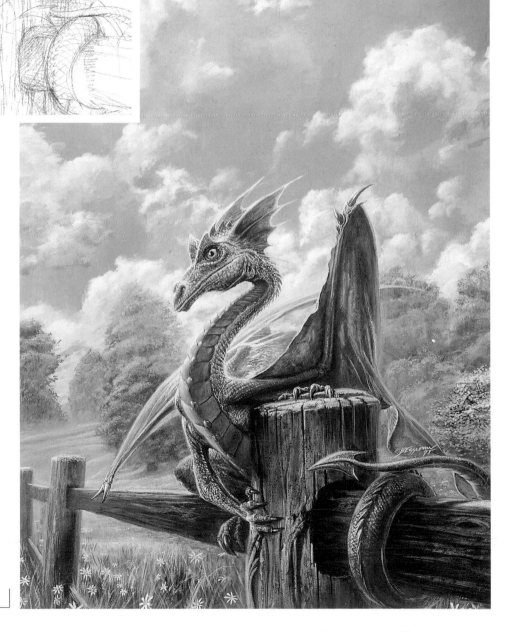

love mythical beasts like dragons, unicorns and griffins. I'm very charmed by good fantasy. The best kind is believable up to the point where the magic comes in and throws things off a bit. But it's hard for someone with a reputation for "hard" science fiction to do fantasy. People would say, "What are you doing that stuff for? Gone childish? Be tight!"

▲ *North Eastern Field Dragon 1995 Initial Pencil Sketch*

Initial sketches are rarely as close to the final painting as this. More often they only make sense to Bob himself.

North Eastern Field Dragon 1995 ▶
Acrylic
18 x 25 in (46 x 63 cm)
Cover Illustration,
Marion Zimmer Bradley's
Fantasy *magazine*

For a story about a small dragon that leads some kids to a magical world. 'I wanted to create a sense of reality by portraying the dragon as in a wildlife painting, against an almost typically suburban field background. I also had to give him a different personality to previous dragons.'

A lot of male fans are like that. A lot of female fans react very positively to my fantasy work though and several have made offers for small dragon pictures.

'I see no conflict between science fiction and fantasy art. You can have too much of one thing, so I enjoy the balance. But I'm tending to gravitate towards picturesque fantasy images.'

Bob's appetite for work is impressive, as is the speed with which he can perform under pressure. Arriving in London for the preparation of this book, jet-lagged and having gone twenty-four hours without sleep, the basic book plan was nevertheless hammered out in almost record time. Several of the best pictures in this collection were produced under similar circumstances. Bob's ability to suspend fatigue for such *tours de force* has to be part of his success as an illustrator, especially with book covers when deadlines are notoriously capricious and fierce, but originality is still expected.

Bob Eggleton was born in Massachusetts in 1960. After his birth his family moved around the States for a while before settling down in Providence, Rhode Island, where Bob and his parents still live. Rhode Island is H.P. Lovecraft territory and so very significant for a fantasy artist, but Bob has no plans to

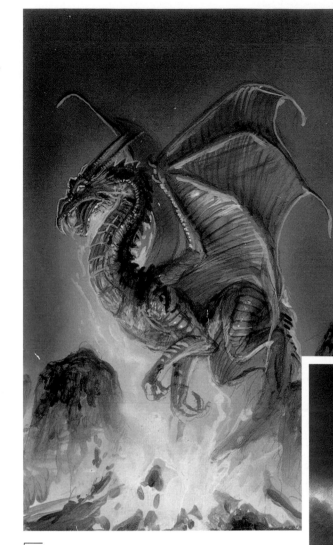

Mountain Dragon 1993 ▲
Colour Rough

At this time, Bob was known largely as a space hardware artist. While not unhappy about this, he welcomed this chance to branch out into fantasy, with its more organic forms. The theme of a dragon's birth is thus particularly appropriate.

remain there indefinitely. 'I find the mind-set a bit discouraging at times. I tend to agree with the saying that the smallest state also has the smallest state of mind. It's very provincial. People say things like, "You don't know what it's like to work, being a pony-tailed artist." It's convenient, though. And I do need to be near the ocean, I feel a real calling to it and often go down there to walk while I sort out ideas. I like to walk the tightrope between urbanity and the wilderness. I need that balance. Maybe the north-west would suit me: somewhere like Seattle, with some of the year spent in England because it's the gateway to Europe. I love the thousands of years of history there; the ancient castles and old, old architecture. That's missing in America, the link with the ancient past. In science fiction I kind of live in the future, but I also like to keep a record of the past. I like the worlds of technology and magic. Science can be too pretentious and magic can degenerate into superstition, but they can balance out each other's faults.'

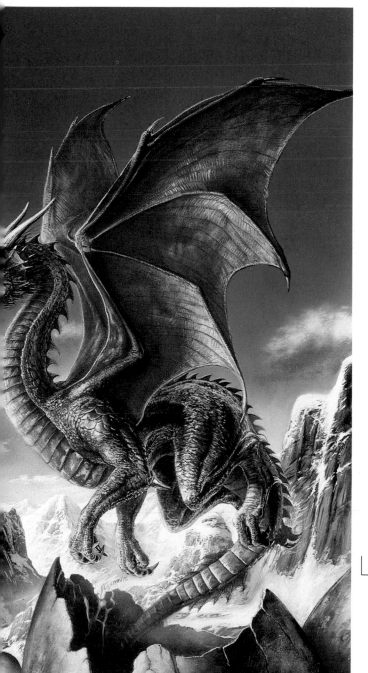

◀ *Mountain Dragon 1992*
Acrylic
21 x 28 in (54 x 71 cm)
Anthology cover, Ace Books

When this image appeared, a common response was 'Gee Bob, I didn't know you could do dragons!' It has been extremely popular and in 1994 won the Chesley Award for Best Paperback Cover. The brief from Ace was very loose. As it was for a collection of dragon stories, almost any kind of dragon would do. This was chosen from two designs, the other depicted a dragon being born amid raging flames. Somehow the contrasts of *Mountain Dragon* were more appealing.

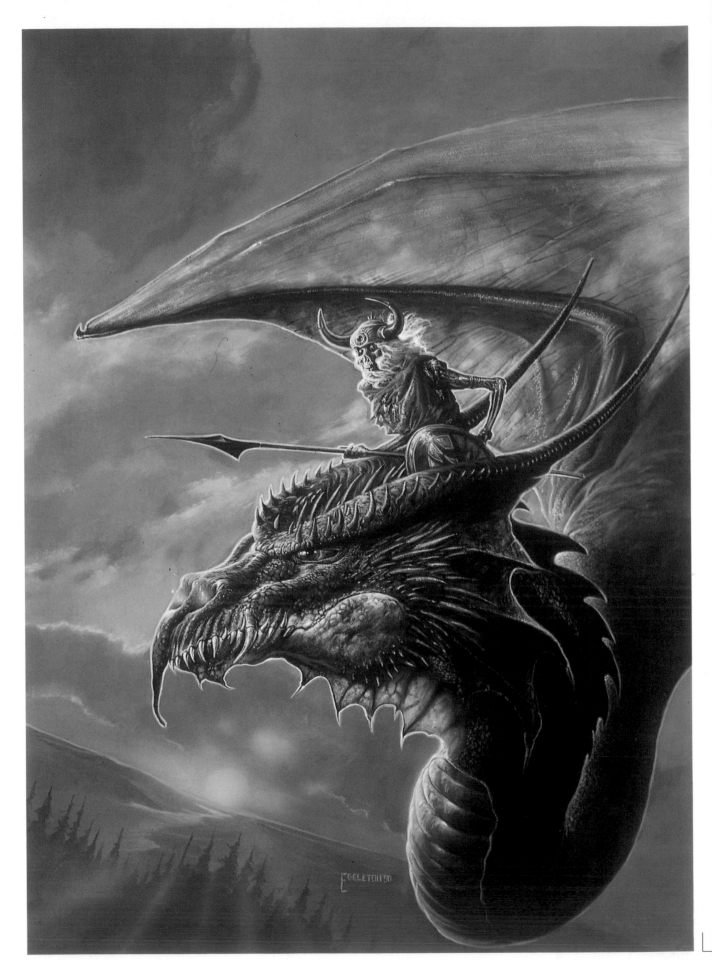

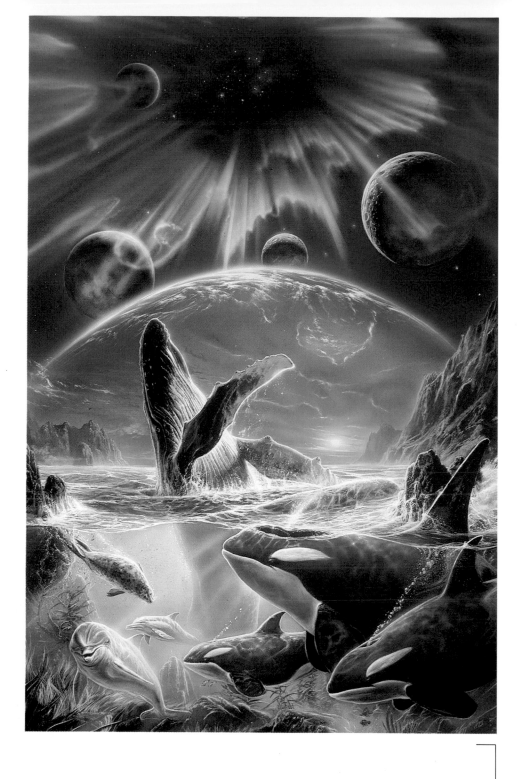

Orcaurora 1993 ▲
Acrylic
24 x 36 in (61 x 92 cm)
Cosmo Merchandising
Poster, Novagraphics

Given the Best of Show Award at the World Science Fiction Convention, this picture was originally commissioned by a company interested in marketing Bob's work in Japan. The northern lights and whales were chosen as a joint theme because both are very popular in Japan. It has proved equally popular as a print in the US, has appeared in calendars and as a jigsaw in Japan and Germany.

◀ *The War Dragon 1990*
Acrylic
15 x 19 in (38 x 48 cm)
Cover, Dragon *Magazine*

This was Bob's first ever dragon painting and to him now seems 'loaded with clichés', but it has proved very popular.

The draw to England is partly a matter of background; Bob's mother is British and he has a clan of close relations in London and the south-east. There are also aspects of life in America from which he would appreciate the occasional break, not least of which is the current mania for litigation, a topic on which he will happily expound at some length, having himself been on the receiving end of it.

Among Bob's scare stories is that of a writer friend who was sued after a book he had written became a success. The lawsuit was taken out by the person who was his landlord at the time he was writing the book, and involved a backdated demand for higher rent

Dankden 1994 ▲
Initial Idea

'This idea came very quickly. The creatures' point of view seemed best and I wanted all kinds of angles to give a sense of chaos.'

Dankden 1994 ▶
Colour Brief
6 x 8 in (15 x 20 cm)

'Done for my own benefit, because I wanted to assure myself of the almost monochromatic colour scheme. This would never work on a book cover because it is too dark. Magazines are a different story though, because the sales base is subscription.'

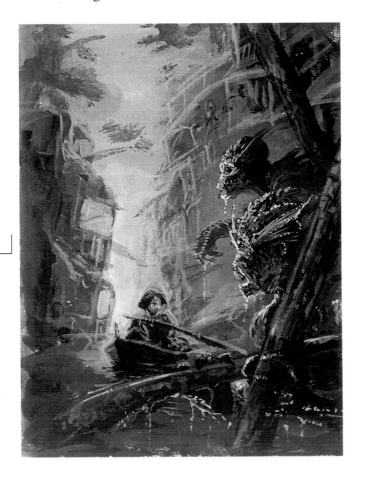

Dankden 1994 ▶
Acrylic
18 x 25 in (46 x 64 cm)
Cover, The Magazine of Fantasy and Science Fiction

'The finish is much looser than normal, but I wanted the sense of movement. The rain and ichor (gooey stuff) were really fun to paint. I eliminated the upper creature, seen in the rough, because he seemed to want to draw your eye away from the central action.'

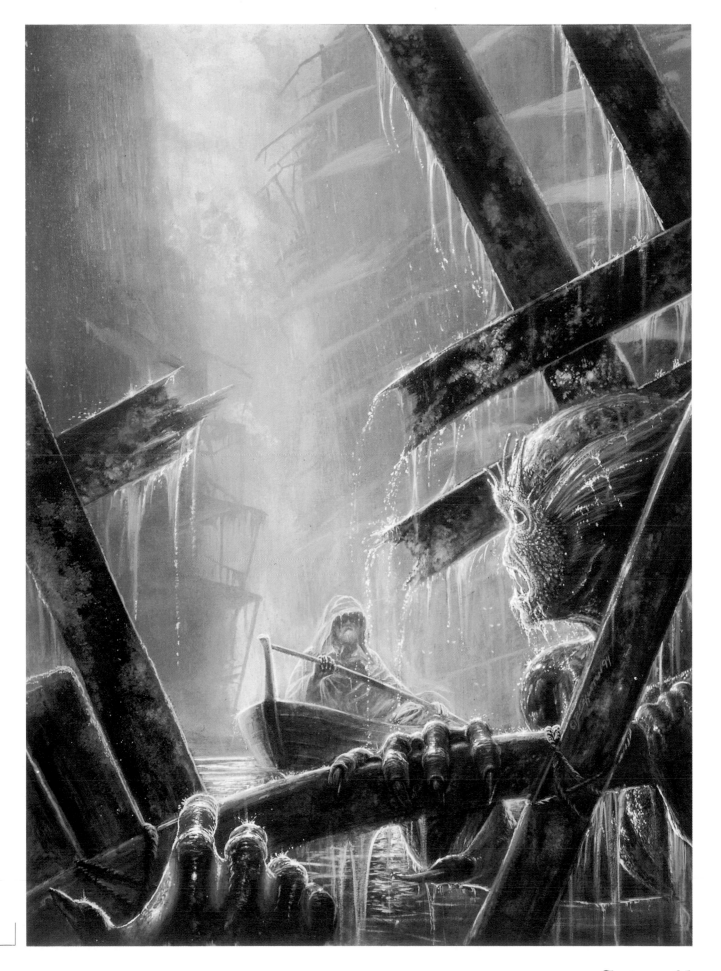

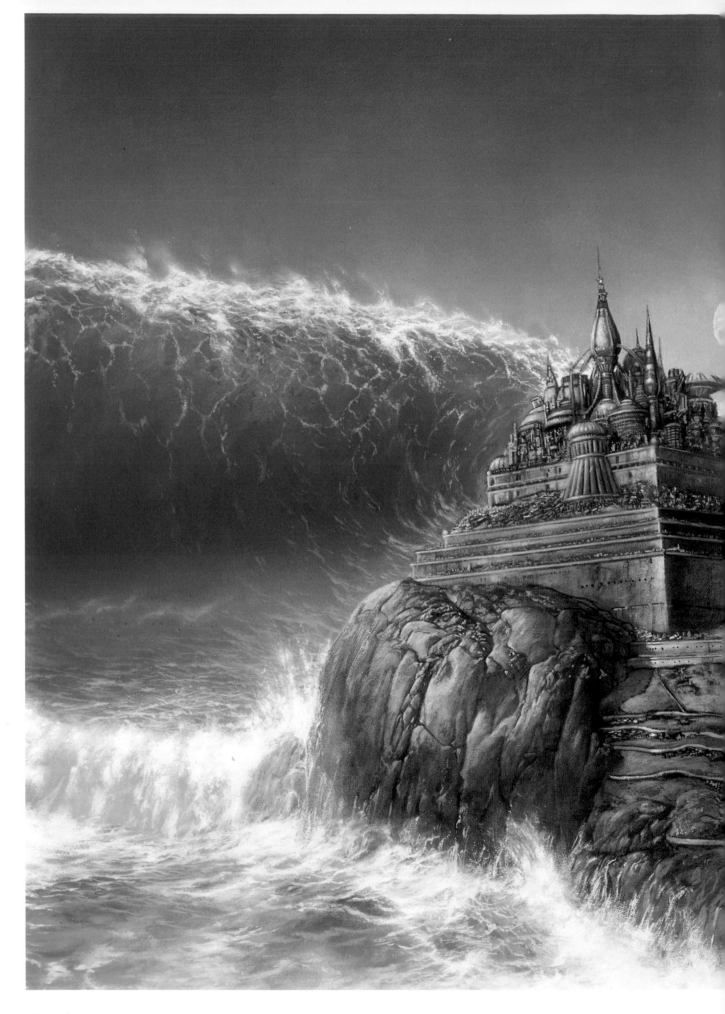

for providing such a fruitful creative environment. The case was thrown out of court but the writer was fined for contempt anyway due to an unconsidered reply to the judge. 'How did this case ever get to court and waste so much of our time?' asked the judge. 'Don't ask me,' replied Bob's friend, 'I've only been defending myself here.'

A Comment on Bob's Work

In my seventeen-year career in publishing, I have worked with many gifted artists. None of these exceptional people can quite compare with Bob Eggleton's talent or colourful personality. Bob has done close to a dozen covers for both Analog and Asimov's Science Fiction magazines over the past nine years. It has been a pleasure to work with him because he has always delighted in giving me exactly what I want.

Each of his covers is quite unique in its own way. The strong similarity that ties them together, and lets you know that all were done by the same artist, is their palette. Bob's trademark is his use of bold, bright, and vibrant colours. In his painting Embracing the Alien Bob's rhythmical conception of space and powerfully organized layers combine with saturated purples and golden yellows. Wave Goodbye depicts a city on an alien planet about to be consumed by a tidal wave. This majestic landscape displays his use of deep blues and richly varied greens. Bob's use of colour in both of these evocative paintings is restrained compared with much of his other work.

Bob is an intelligent artist to work with. His knowledge of astronomy and sciences in general adds accuracy to his portrayal of astronomical subjects. Two excellent examples are Martians and Highclimber. In both instances Bob had to do extensive research to obtain the reference material crucial to the work done on these covers.

Bob is very much liked and respected by the readers of Analog and Asimov's. They have displayed their affinity for his art by twice voting him their favourite cover artist at both magazines. Bob is also a winner of science fiction's prestigious Hugo Award for Best Professional Artist. He received this long overdue and well deserved honour in 1994 at Conadian in Winnipeg. It gave me great joy to phone Bob from Canada with the good news. He hadn't expected to win the Hugo and did not attend the convention until after the ceremony. That night, though, he was on a plane to Winnipeg, and a day later I had the pleasure of watching him accept his Hugo at the masquerade party.

I am both proud of and delighted by Bob's accomplishments. I am sure the years will bring me many more of his beautiful covers, and I look forward to each and every one of them.

Terri Czeczko,
Art Director,
Analog and Asimov's Science Fiction magazines.

◀ *Wave Goodbye 1991*
Acrylic
11 x 14 in (28 x 36 cm)
Cover, Isaac Asimov's
Science Fiction Magazine

Illustration for *Stations Of The Tide*
by Michael Swanwick.

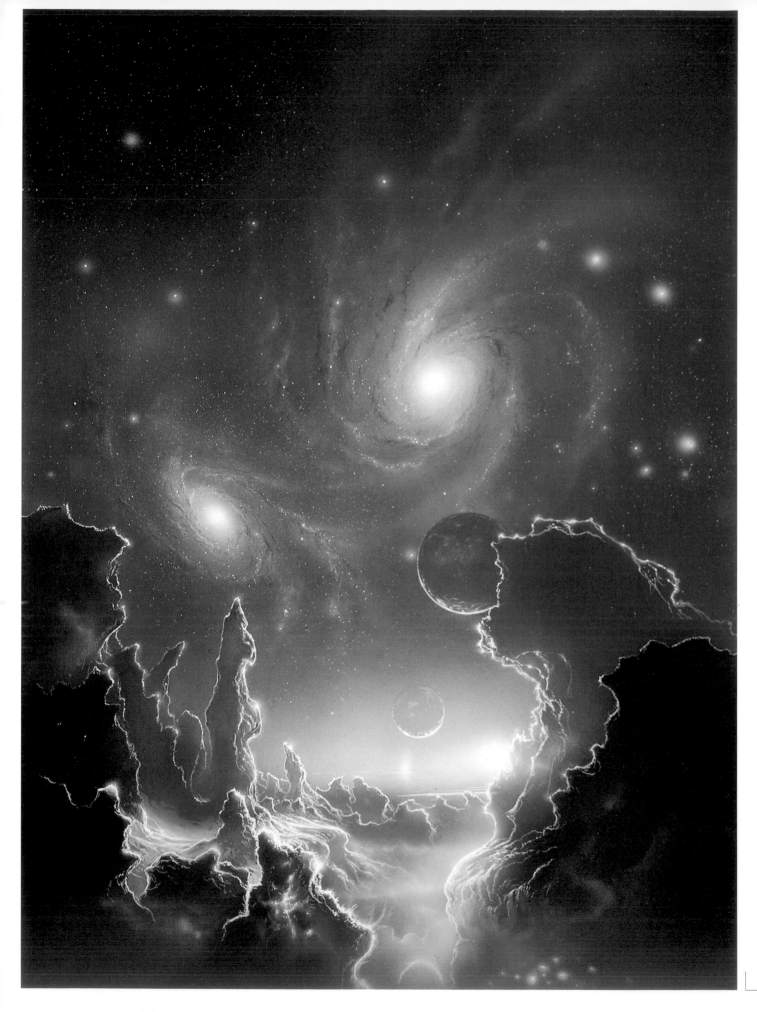

Cosmic Lights & Darks

'**I** *love the starkness of space* and the way it makes you feel very small. A lot of artists try to be too hard-core about it, too mathematically accurate. I appreciate this but am not personally into the maths. My approach is more awe-struck.'

The drama of Bob's space paintings is impressive, particularly when there is no human element in them for the viewer to identify with. The drama is that of the elements themselves, indifferent to humanity. 'If you paint spacescapes without the human figure they remain timeless. What you also have to remember is that 90 per cent of the painting is black. You have to think in negative. Once you can do that, playing with the abstract elements becomes fun.'

One space artist he admires enormously is Ludek Pesek, who also manages to inject drama into his spacescapes, and who turned out many famous paintings in the 1960s and 1970s, including some beautiful panoramas of Mars with blue skies. Was the artist despondent when probe photographs proved this wrong? Not at all, he renamed them *When Mars Had Blue Skies*.

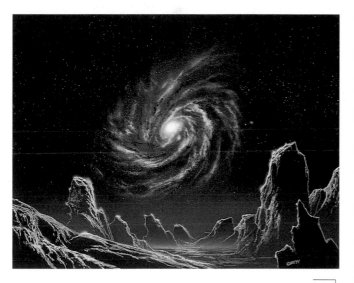

Far Off 1994 ▲
Acrylic
12 x 9 in (30 x 24 cm)
Unpublished
Produced quite rapidly for a gallery show, this is an example of the small paintings Bob happily produces for 'the client with the smaller budget.'

◀ *Thaw 1993*
Acrylic
18 x 25 in (46 x 64 cm)
Cover, Amazing Stories *magazine*
'This magazine had a great cover policy allowing artists to do whatever they wanted. They paid good too! What I wanted was to show a fanciful scene of two interacting galaxies seen from a planet with two moons. The planet has a wildly elliptical orbit taking it very close to the sun every thousand years or so, thawing out the great ice formations that have crystallized over the millenium. A phosphorescent life form can be seen at the bottom.'

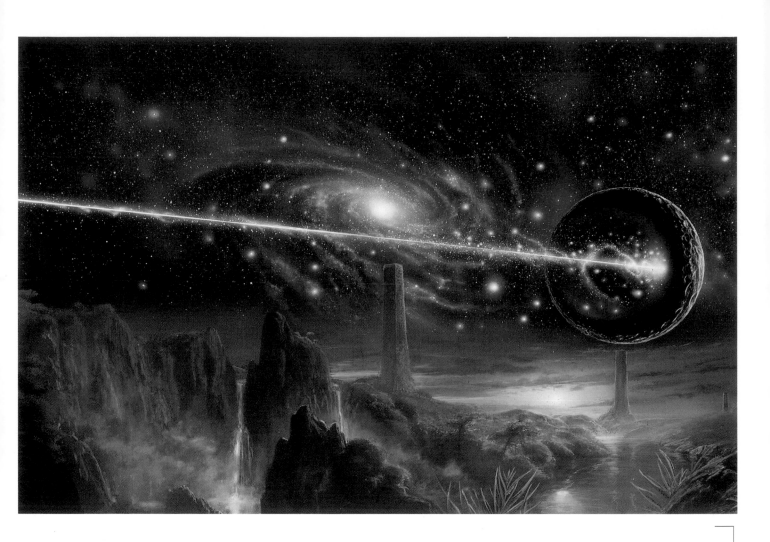

Some of this insouciance has rubbed off on Bob who occasionally paints scenes he knows are totally unscientific. 'When comparing photos of the moon with, for example, Chesley Bonestell's visions, I'm often tempted to think it must be the moon that's wrong.'

The pictures in this chapter are a mixture of fact and fantasy. Some are illustrations for scientific journals and some for fiction. The difference is not always obvious. In fact some of the purely factual pieces are the most bizarre or romantic. The view of the solar system from the outer reaches of Pluto in *Pluto and Charon* (see pp. 42–43) looks like

Legacy 2 1994 ▶
Acrylic
20 x 24 in (51 x 61 cm)
Book cover (UK),
Legend Books
Author Greg Bear

John Jarrold at Legend liked the US cover so much that he commissioned something similar for the UK edition. In fact Bob slightly prefers this version.

▲ *Legacy 1994*
Acrylic
30 x 20 in (76 x 51 cm)
Book cover (US), Tor Books
Author Greg Bear

This was a very closely directed, conceptual piece as the publishers very much wanted a 'big book' feel. The story revolves around a giant asteroid called Thistledown which serves as a corridor through space and time between various worlds. This was to be set against a backdrop of stars and a foreground reminiscent of a Frederick Church alien landscape. Everyone was very pleased with the result.

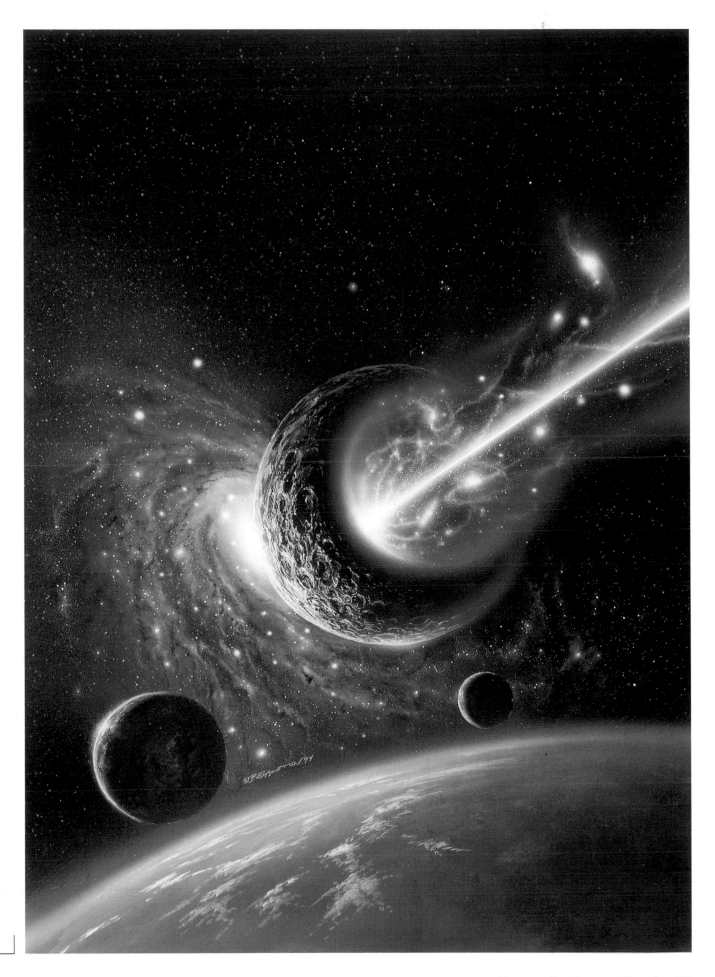

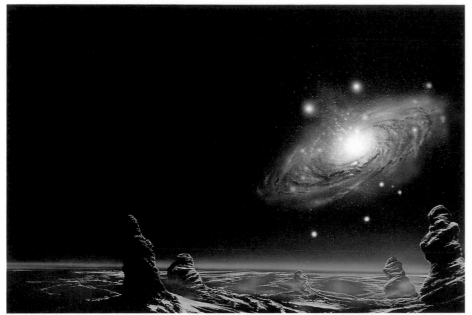

◀ *Alone 1989*
Acrylic
30 x 20 in (76 x 51 cm)
Anthology cover,
Tor Books/Nesfa Press
Editor Andre Norton

A simple and easy painting that was completed in an afternoon. A requirement was to hint that the book contained a collection of Nebula Award-winning stories without being too obvious.

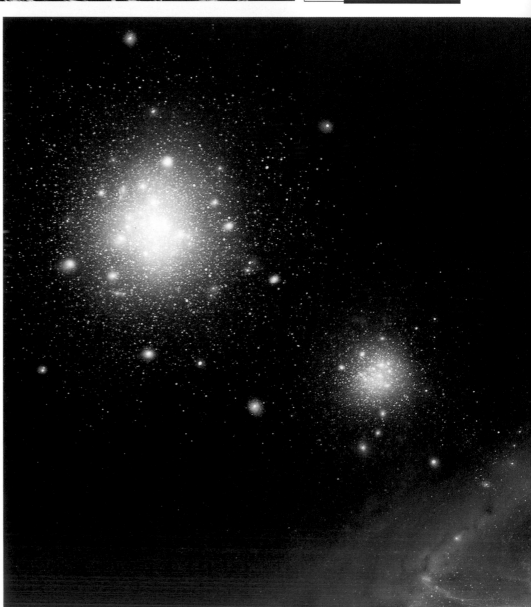

Drifting 1993 ▶
Acrylic
30 x 20 in (76 x 51 cm)
Interior Illustration,
Astronomy *magazine*

For a science fact article about globular star clusters outside the galactic plane.

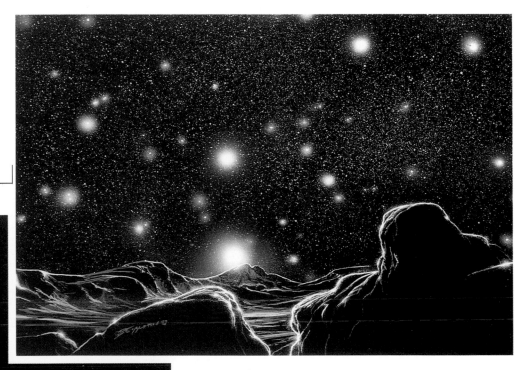

Inside the Cluster 1993 ▶
Acrylic
17 x 12 in (43 x 30 cm)
Interior illustration,
Astronomy *magazine*

What you would see from
inside one of the globular
clusters, standing on an airless,
icy world illuminated by
literally millions of suns.

the faithful reworking of a probe photo. In reality there is no such thing as yet.

Part of the attraction of pure spacescapes for Bob is that he sometimes finds the world very crowded. 'Pictures of space without people remind you of primeval loneliness. Sometimes putting a figure in a painting spoils it a bit for me. It's like it's already inhabited so there's no invitation to walk into it.

'I like painting galaxies a lot because you have an entire cosmos, four hundred billion stars say, in one eyeful. You realize, looking at this giant pattern, that we are part of something similar, and that the spiral pattern that's repeated throughout nature is repeated

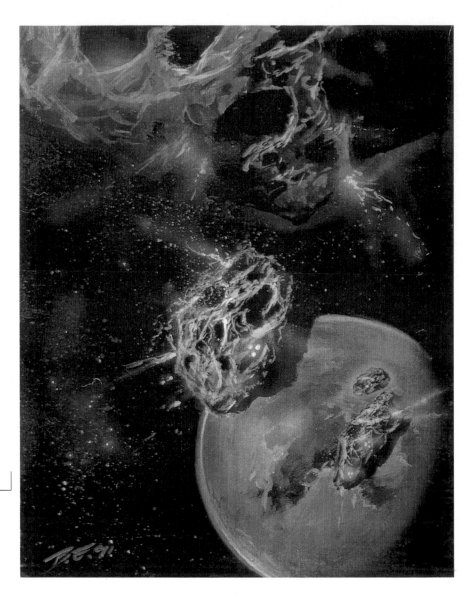

in galaxies on the grandest scale of all. You realize that
gravity, which makes the bathroom scale turn, is the
basis of all things.

'Usually there's a planetscape in the foreground of these
pictures and I particularly like doing planets from beyond
the solar system, which has been quite thoroughly
explored. Often there's a trickiness, though, in creating a
horizon without the benefit of an atmosphere to blur it,
something which has disconcerted visitors to the moon.
Another problem generally with astronomical art is that
the compositions end up so blatantly simple you have to
be careful that you're not copying someone else's picture.'

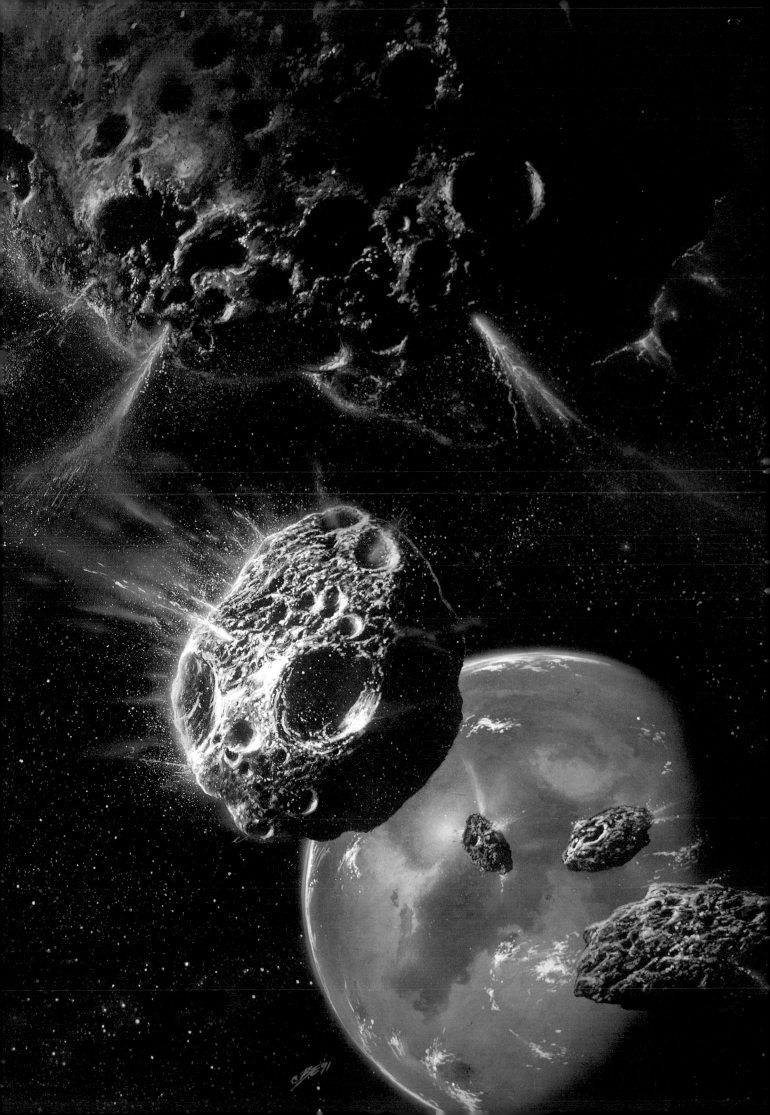

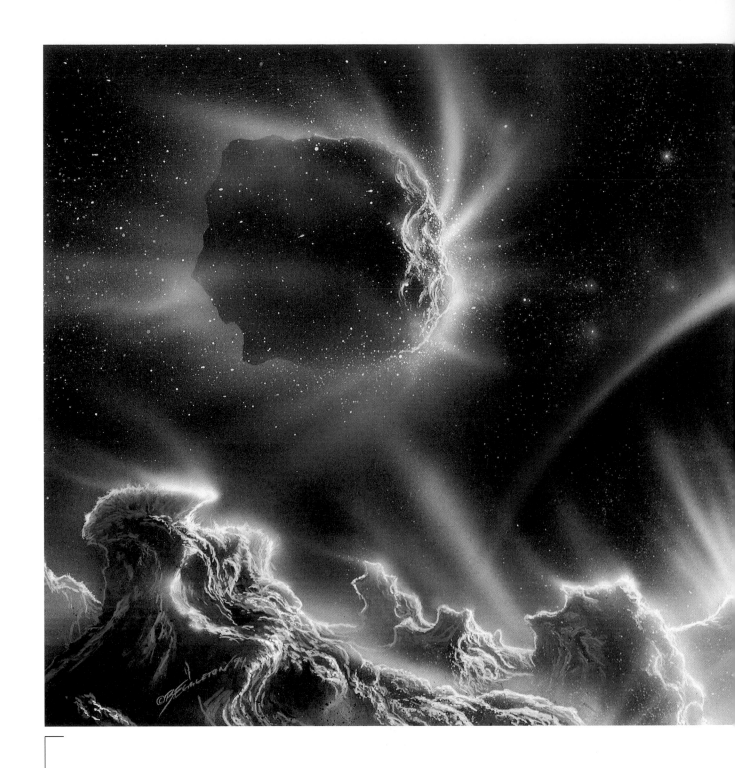

Inbound SL9 1994 ▲
Acrylic. 25 x 12 in (63 x 30 cm)
Unpublished

Comet Shoemaker-Levy 9 became the
focus of much attention in July 1994 as it
hurtled along a collision course for Jupiter.
'This is one of those instances when the
accuracy of a painting can go out of the
window overnight. We all sort of knew
what the comet looked like but not what
would follow. I played safe, as in many of
my fictional paintings, and showed the
moment just before the action takes place.
Oddly, I seem to be the only artist who
picked a point of view on the comet as it
was disintegrating under gravitational
forces, and its gaseous transformation just
starting. This afforded me the chance to
have a lot of fun with colours and lighting
effects.' This picture has been reproduced
in various forms in the US and Europe.

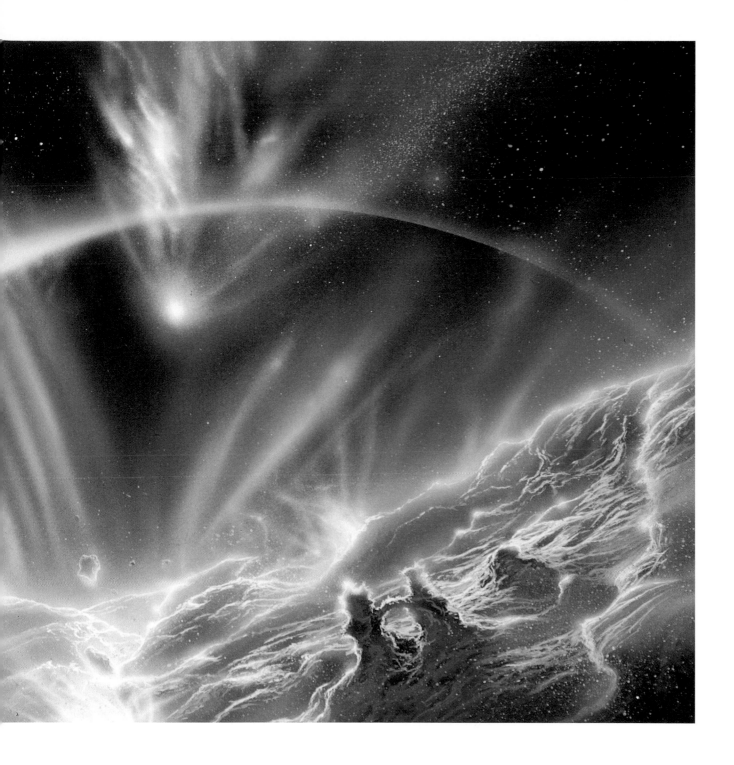

Although half in love with science, Bob has reservations, 'I have a problem with its pretentiousness. Scientists often give the impression of knowing it all but, as the Hubble space telescope proved, they often don't. I admire Stephen Hawking with his wild predictions about things like black holes that later turn out to be true. In some people like him science and art meet.'

Art came early into Bob's life. 'I was a sickly child. From about 18 months I seemed to get just one virus after another. At one point I became quite a

hypochondriac, which I got over. I was an only child, didn't go out a lot and so hadn't many friends. For a time my best friend was a blackboard which I filled with alien critters and wild space voyage scenes. At the time I wasn't always too happy with my life, but looking back I have no regrets. There's not much I would change.'

In tandem with art ran an 'almost religious' fascination with the Gemini and Apollo space missions which led to him being called on to lecture the rest of his second grade class about the subject, casually trotting out terms like 'oblative material' and 're-entry angle' as if they were self-evident. The two naturally combined.

In art classes he soon made a mark on his teachers. The first

Ganymede 1991 ▼
Acrylic
22 x 14 in (56 x 36 cm)
Unpublished

A highly astronomical painting showing the view from Jupiter's largest moon. Like many such pictures it is an exercise in contrasts, and in juggling the basically simple elements.

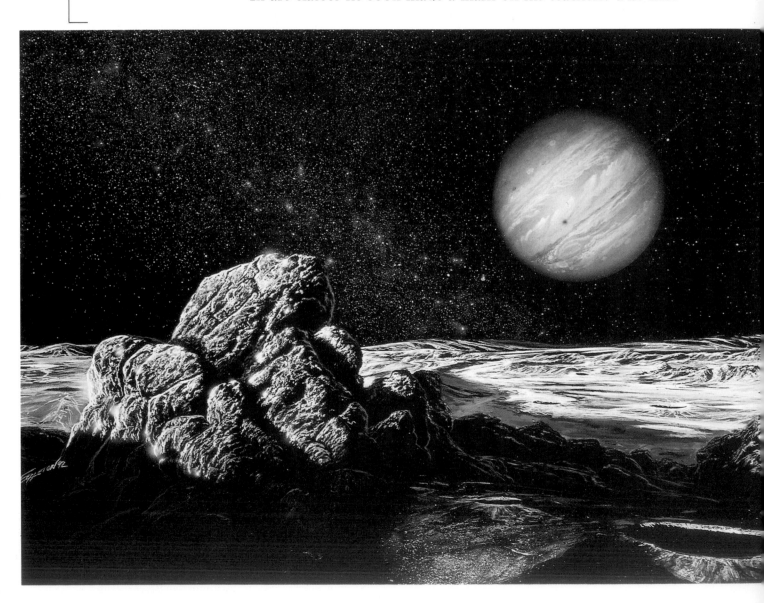

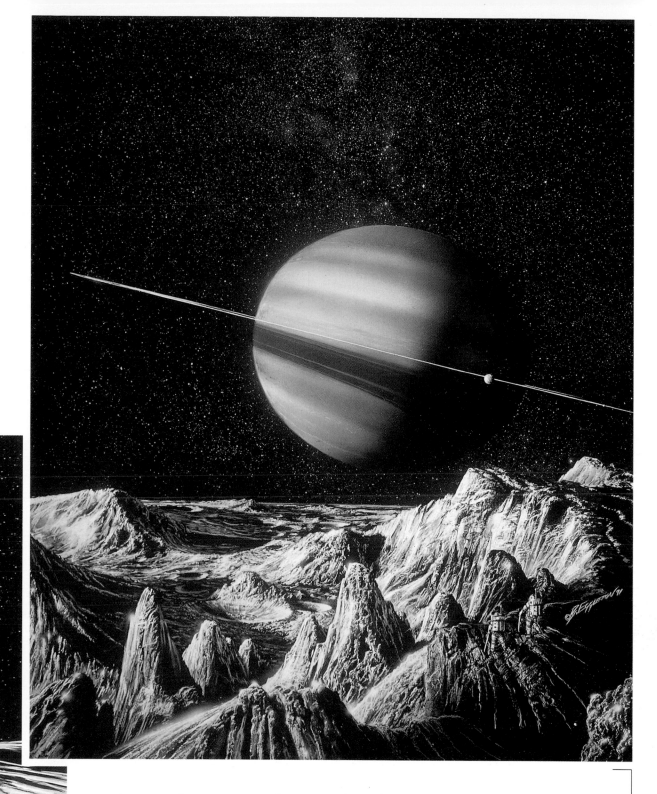

instance he can remember was when they were asked to make pictures out of cut-out shapes. The theme was sailing boats and what amazed the teacher was Bob's use of triangles of various sizes to create an illusion of perspective by placing them one behind the other. The use of perspective came naturally

Saturn 1991 ▲
Acrylic
18 x 24 in (46 x 61 cm)
Cover Amazing Stories
magazine, & Year's Best SF,
St. Martin's Press

This is more a homage to Chesley Bonestell's romantic space visions than an attempt at accurate portrayal. Bob wanted to show how Saturn's moons might have been imagined before the Voyager space probes proved otherwise.

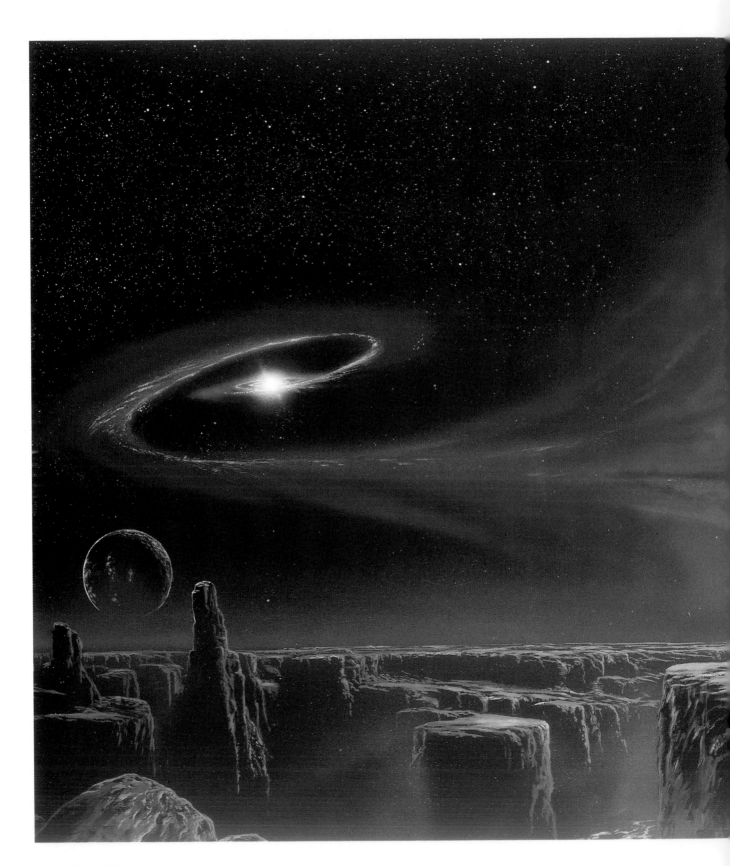

to Bob at the age of about 6, without any tuition that he can remember. 'It just seemed right to do it. Even then I didn't believe in following convention. You know, straight line work with no depth. While the rest of the kids were drawing cute little houses I was practising mechanical perspective.'

Did he get much encouragement at school? 'From some teachers, but on the whole not. Remember this was in the 1960s when the Vietnam war was raging and there were massive youth protests on campuses and elsewhere. Lots of parents and politicians panicked. Teachers too. There was a great pressure on the rising generation to conform, to stop them going wild like their older brothers and sisters. The more I was pushed to conformity, the more I rebelled against it.'

Along with the space program Bob fell in love with *Star Trek*, which he still enjoys in both its original and more recent incarnations.

◀ *David & Goliath 1990*
Acrylic
30 x 20 in (76 x 51 cm)
Interior Illustration,
Astronomy *magazine*

What we are seeing here is a giant red star having its substance sucked away by the tiny but enormously dense neutron star that will ultimately destroy it. The landscape in the foreground is cracking up because of volcanic activity caused by the surging gravitational flux. Although a science fact illustration, it has proved popular all round, becoming a very successful print and having been reproduced countless times in Europe and Japan.

One of the satisfying treats of his chosen profession is having been asked for material relating to the series.

His 'road to Damascus' experience though, the thing that jolted his life on to its present course, was going to see the film *2001* at the age of about 9 with a party of other kids and adults. 'It changed my life. After *2001* I started realizing there was something big going on that I hadn't been told about. I came out charged with energy. Just as in the film the monoliths implanted an idea in apes' minds, so something was implanted in mine. Amazingly, I seemed the only one of the group who could understand the movie, and explain it to the others who just sat there with question marks in their minds.

'Until then I'd been quite accepting of the Judaeo-Christian religious equation, but I began questioning things like the ideas of the *Book of Genesis*. I wanted to know where the Big Bang, dinosaurs and early man fitted in. I began to be considered basically a threat to anyone religious. Now I'd say I'm an agnostic, I believe there's something going on but don't know what. My family's the same way too, to a degree, so there's no problem there. However, I have had acquaintances who have been bothered by my views. They tell me they pray for me.'

So he had found a vocation, but it met with little official encouragement. Guidance counsellors and teachers always tried to talk him out of art, saying it was no way of making a living. For a time his main inspiration was horror in general and Japanese fantasy monsters in particular, 'People said "where is this interest in monsters and horror going to get you in life?" Years later when I got a cheque for some horror paintings I wished I could

▲ *Red Dwarf Stars 1990*
Acrylic
30 x 21 in (76 x 51 cm)
Interior Illustration, Astronomy *magazine*
Red dwarf flare stars embedded in a gaseous cloud passing through the Pleiades star cluster. 'While these factual images don't pay the best, the satisfaction more than makes up for it. And the exposure, because these magazines are seen all over the world and lead to other commissions.'

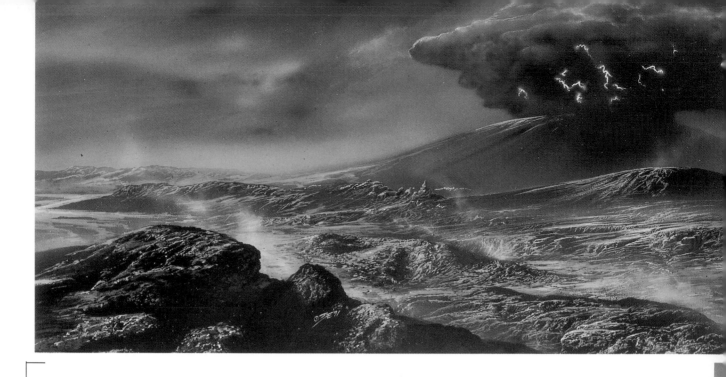

Venusian Eruption 1992 ▲
Acrylic
30 x 15 in (76 x 38 cm)
Unpublished

The second of a pair of very factual Venusian pictures. 'Many years ago it was thought that Venus was a "prehistoric" world with jungles, dinosaurs and, in one film, Mamie Van Doren. In fact, Venus is a dead, broiling hot world of sulphuric acid clouds, pressure ninety times that of earth and volcanic mountains. The pressure is so great that ash and gas escaping from an eruption would be caused to drift downwards, with lightning storms in the clouds.'

Venusian Impact 1991 ▶
Acrylic
12 x 12 in (30 x 30 cm)
Cover illustration,
Astronomy *magazine*

Venus has many craters caused by the impact of massive meteorites. Here is one such, scattering material away from it for quite a distance.

go back and wave it in their faces and say "here is where it's got me. It pays the rent".'

From school Bob went to art college in Rhode Island, thinking this was the way forward. He was mostly to be disillusioned, though one or two teachers stand out in his memory for being helpful. In particular Enrico Pinardi, a man who believed that if you really wanted to do anything original with your life it would be a struggle. So to prepare his students he made life as hard as possible for them, saying, 'You're going to have to put up with people like me all your life so you'd better get used to it.' More immediately useful was his belief that all art sprang from drawing, which, against the general trend, he encouraged among the students. Finding little encouragement for the kind of art he was interested in, Bob left after a year and a half and took casual work while he considered his future.

The most useful of his manual jobs was in a graphic art store catering for art students who came to experiment with paints and other materials, and discuss ideas. Through them Bob's art education continued vicariously. He also started freelance illustration for some local companies, science fiction fanzines and the like.

A big turning point was the World Science Fiction Convention in Boston in 1980. On the off-chance he entered several line drawings in the art show and by both popular and professional vote was awarded the prize for Best Monochromatic Artist in the Amateur Division. 'I went in an amateur and came out a professional. I was stunned by the prize and looking round at all the artwork I realized that this was what I wanted to be part of.'

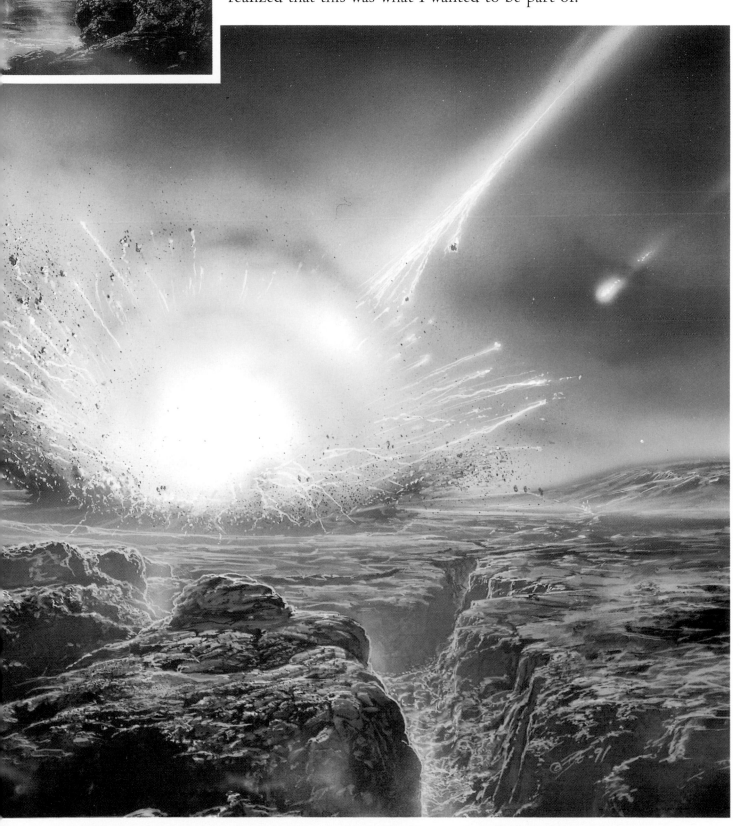

What did his family think of the course he was on? 'I think they realized I could have been doing far worse things. It's quite easy in the States to just bum around. There's also been a lot of "downsizing" going on in business. Now kids, after a $90,000 education, go out looking for jobs and find there aren't any. There's been a whole generation who don't really want to get out of school. When they have to they just take a dull job that doesn't pay anything and live with their parents till they're 40. At least I wasn't doing that. But my mother was concerned about what exactly I was going to do with my life. My

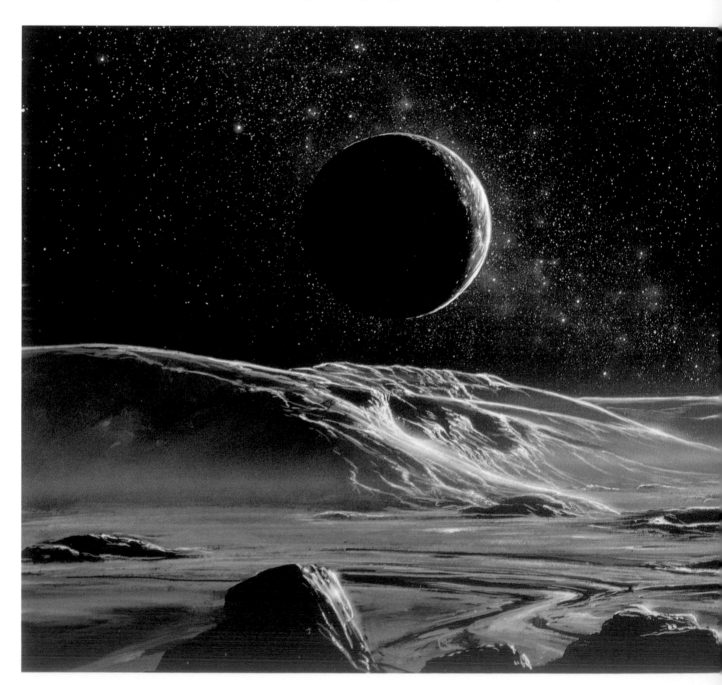

father less so. He's a bit of an inventor, I get much of my mechanical-mindedness from him. He's an engineer, self-taught and creative in his own way. He was always half on my side and is very happy now that I "took the bull by the horns" and have succeeded.'

Encouraged by the success of his first convention, Bob began attending as many others as possible and found them a tremendous education. 'The best classroom in the world. Through conventions I casually acquainted myself with an entire career, meeting people I

Pluto & Charon 1993 ▼
Acrylic
25 x 13 in (63 x 32 cm)
Art Print

The last planet, Pluto, actually has a twin. Its large moon, Charon (ferryman to hell in mythology), looms large in the sky while the sun is reduced to a small bright eye in the distance. The tiny stars clustered around it are the inner planets. This would be summer on Pluto, with a purple mist of methane spread thinly over the surface.

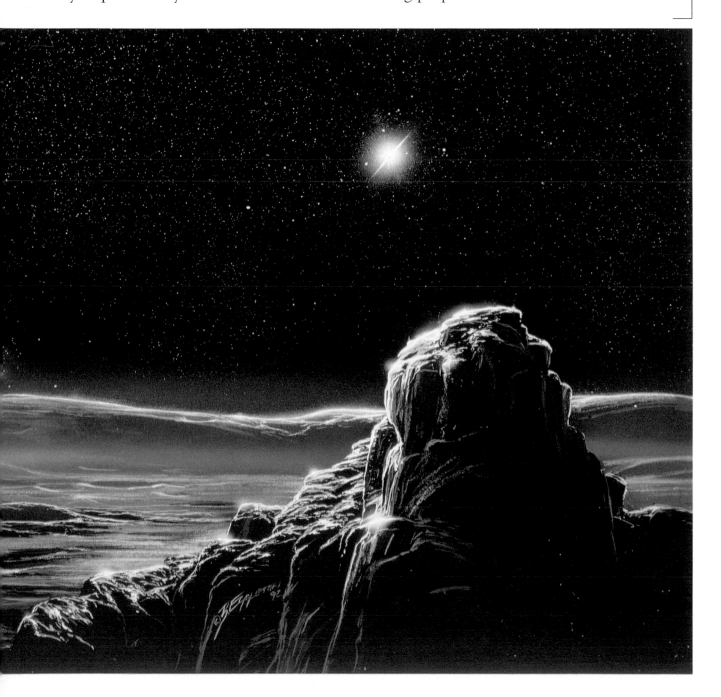

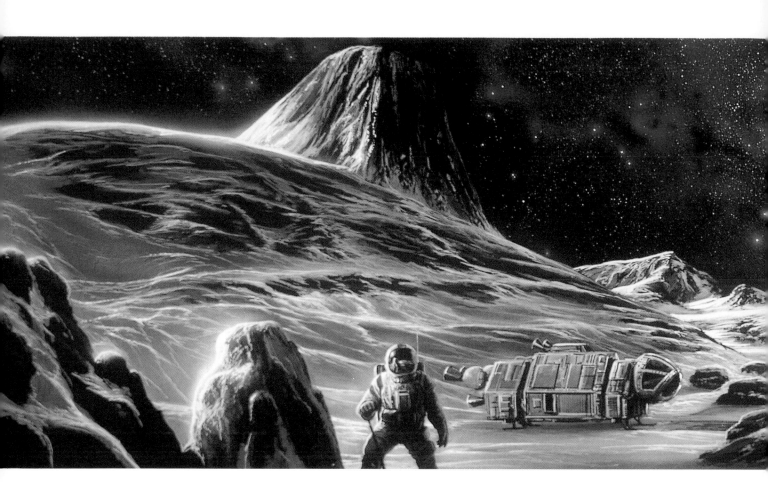

would never have met through the usual channels. Many of the same people go to all the cons, so there's a continuity. It's good seeing the work of other artists and meeting them. There's a camaraderie that exists in no other field of art at all. All shields are dropped, no pretensions. There is some rivalry but it's all very gentlemanly, no cut-throat stuff.'

Among the artists he first met were Michael Whelan, Don Maitz and Kelly Freas, and it was Freas who said, 'Your pictures are great, but now you're going to have to paint.' This advice was echoed on all sides: there is only so far an illustrator can go with black and white.

'I was really afraid of painting for a long time, but finally I launched into it straight off. Then through shows and magazines my work started to be noticed in the right places and I began doing science fiction covers for Baen Books, mainly "hard" spacescapes with lots of machinery, and everything launched from there. One project just led to another.'

1986 saw Bob appearing for the first time as a major guest of honour

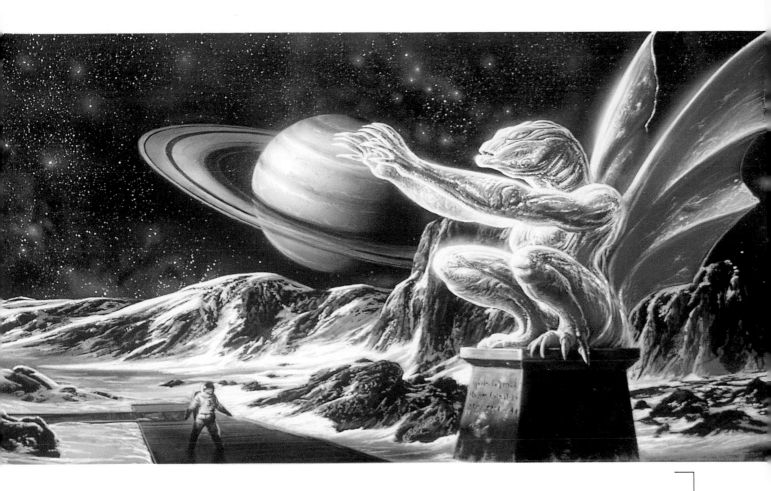

at a convention. A natural aptitude for public speaking emerged when he was asked to entertain the audience off the top of his head for twenty minutes or so because the scheduled speaker was missing. He has since been invited to many others, particularly the World Science Fiction Convention at which he has been nominated for the Hugo Award for Best Professional Artist six times, winning it in 1994 in Manitoba, Canada. The Chesley Award for Best Magazine Cover has also come his way.

As a guest of honour Bob is often required to sit on a panel with others and field questions about all aspects of his work. The misapprehension he most commonly meets with is that of fans assuming that artists have a totally altruistic angle on their work, 'But of course your client pays for it. It's not purely for your own satisfaction.'

▲ *The Engines Of God 1994*
Acrylic
28 x 7 in (70 x 18 cm)
Book cover, Ace Books
Author Jack McDevitt

Designed as a wraparound cover with the art thin and 'panelled' so large type can be added top and bottom. 'It's an incredible novel about alien contact. Ace told me more or less what they wanted, and on reading this scene I agreed it would make a great cover. So everybody was happy, especially the author who purchased the original. I particularly enjoyed it because I have a feeling that in Man's exploration of space he'll find that not only is he very small against the stars, but maybe also against some of the other beings he finds out there.'

Horns & Teeth 1993 ▼
Acrylic
28 x 13 in (71 x 33 cm)
Unpublished

'In this painting I wanted to do an accurate portrayal of dinosaurs of this era. A Triceratops is foraging for food after volcanic activity has laid waste to most things. The Tyrannosaurus is also looking for something to eat, Triceratops being the main course. I think he'll prove a harder meal to catch than the other suspects! I like horizontal formats like this, they tend to give an epic feel to the picture.'

This painting has received compliments from many people, including special effects master Ray Harryhausen, and others who have just enjoyed the echo of Charlie Knight's paleo-artwork for the New York Museum of Natural History.

Dinosaur Sketch ▶
Pencil

'Work-ups for another idea. Just as I like to create drama in astro-art, so I like to create personality in dinosaurs. Some scientific types would argue with this, but my answer is — that is why we have art.'

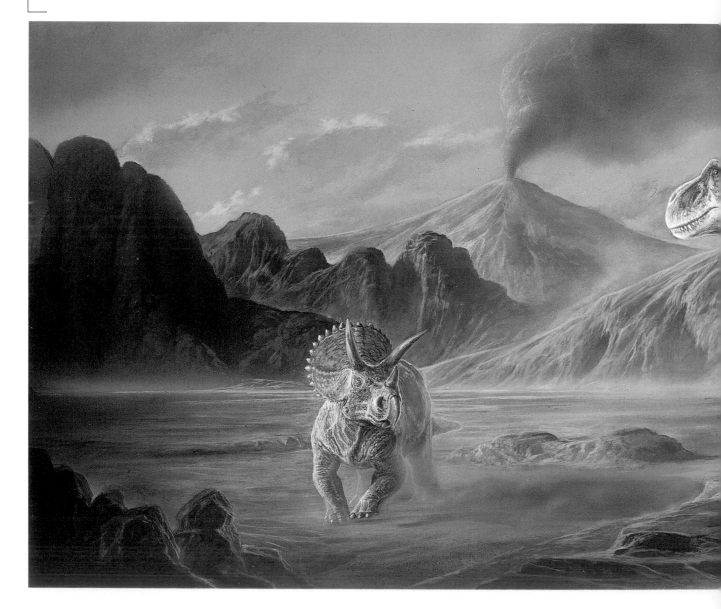

Aliens, Dinosaurs & Other Citizens

Bob Eggleton is a great fan of dinosaurs and is happy to discuss them at great length. 'I love painting them, and have done ever since I can remember. It's the power of their primal ferocity, and imagining a planet, this planet, ruled by these alien creatures. We're now at the top of the food chain but once it was dinosaurs. They flourished for millions of years before suddenly dying out.

'I often wonder what it would have been like if they hadn't died out. You look at the most intelligent of them and think: well maybe they could have evolved into something like us. When I look at birds I can't help but think of their direct descent from dinosaurs. People often accuse me of thinking too deeply about things like this, of being too analytical, but I cannot help it. I enjoy it. When doing a charcoal sketch or using certain paints it's great to think the materials come from the dinosaur age. Especially when working on an actual dinosaur picture because then the fossils are kind of creating themselves.'

Since childhood Bob has collected and built dinosaur models and these infest his studio, often forming the basis of the aliens in his pictures, or at least serving as models for light and shade. Alongside them are hordes of

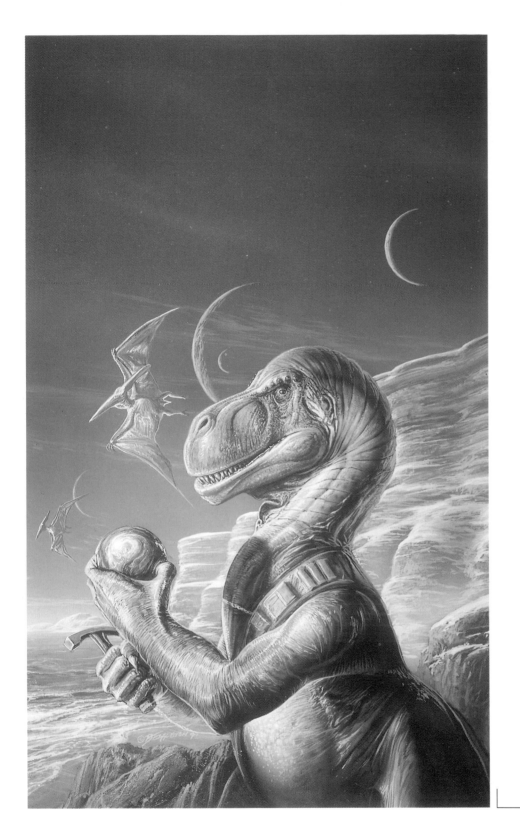

◀ *Fossil Hunter 1992*
Acrylic
12 x 18 in (30 x 46 cm)
Book cover, Ace Books
Author Rob Sawyer

'Rob Sawyer did a good job creating a world where alien dinosaurs have evolved into intelligent beings. He also did a good job giving me some visual stuff. I could have done the scene narratively, but Ace Books wanted "portraits." The dinosaurs are Nanotyrannosaurs (miniature, human-sized Tyrannosaurs). Here we have a male of the species, and in Foreigner a female. I hope you can see the difference!'

more fanciful monsters, particularly 1950s classics like Godzilla and the Creature from the Black Lagoon; plus countless plastic robots and spaceships, any of which might serve as a springboard for Bob's own ideas.

Foreigner 1993 ▶
Acrylic
20 x 30 in (51 x 76 cm)
Book cover, Ace Books
Author Rob Sawyer

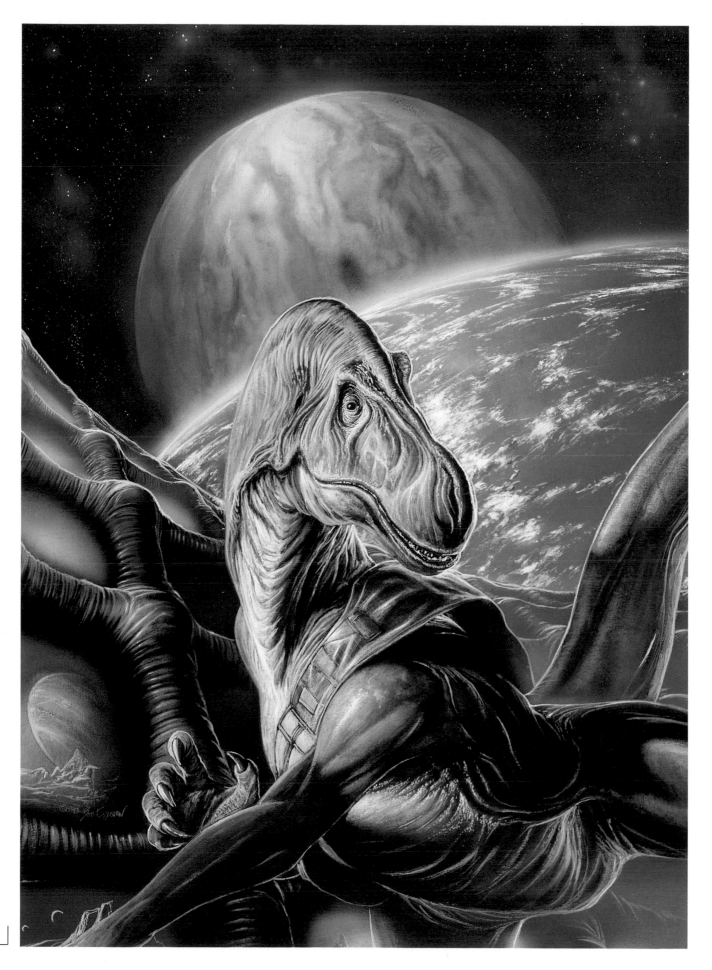

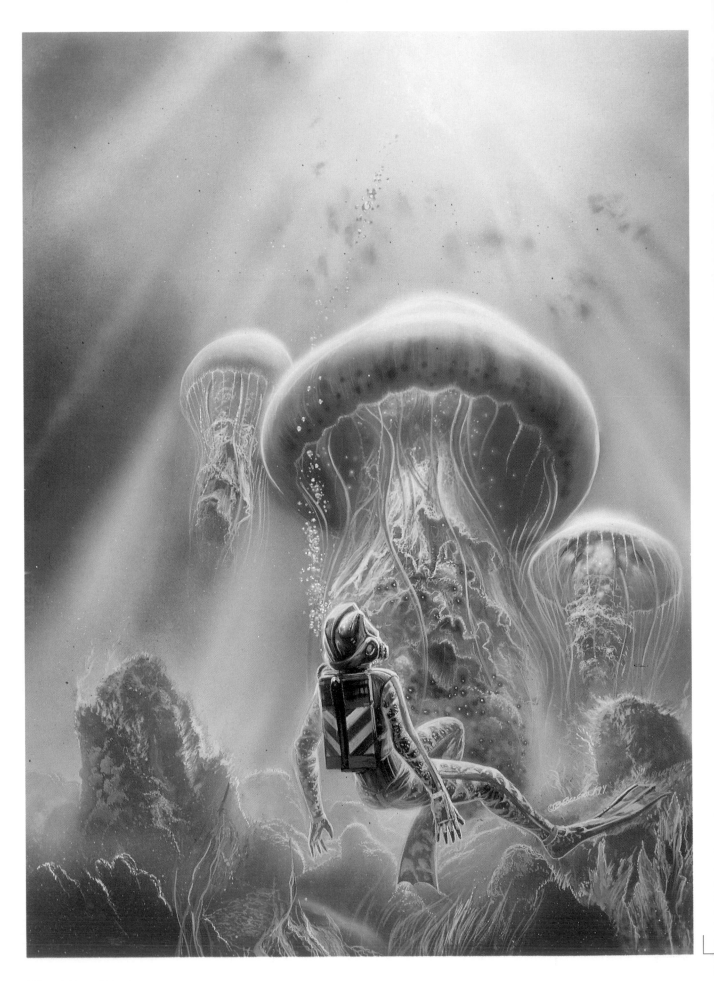

Mistwalker 1992 ▲
Colour rough

A passing idea that later
came in useful for a
commissioned piece.

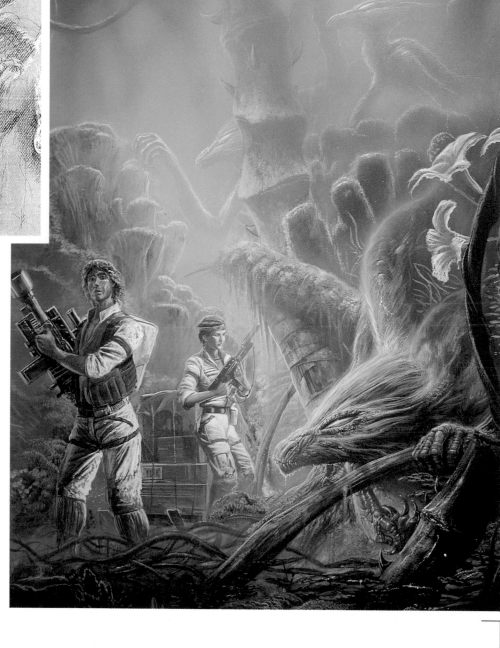

◀ *Tide of Stars 1994*
Acrylic
13 x 18 in (33 x 46 cm)
Cover, Analog *magazine*

For a short story by Julia Ecklar set
on a mostly ocean-covered world.
'The giant jellyfish are not unlike
those of earth's oceans, showing
that form will follow function in
most parts of the universe.'

Mistwalker 1993 ▲
Acrylic
18 x 28 in (46 x 71 cm)
Book cover, Del Rey Books
Author Denise Lopes Heald

'This story had a great "pulpy" feel
so I went for that mood on the cover.
Here we have some humans arriving
on a jungly planet and at risk from
the various jungle flora and fauna.'

When none of these serve, he makes his own models with modelling paste, Plasticene or anything else that comes to hand. There are dangers though, 'I'd love to have the time to get into sculpture, so when I start modelling I tend to get carried away, forgetting that the object is to paint the thing. I get a bit obsessional, and it can be dangerous when you're on a deadline. The wonderful thing about sculpture is you don't have to pretend to create three dimensionally because you're actually doing it.'

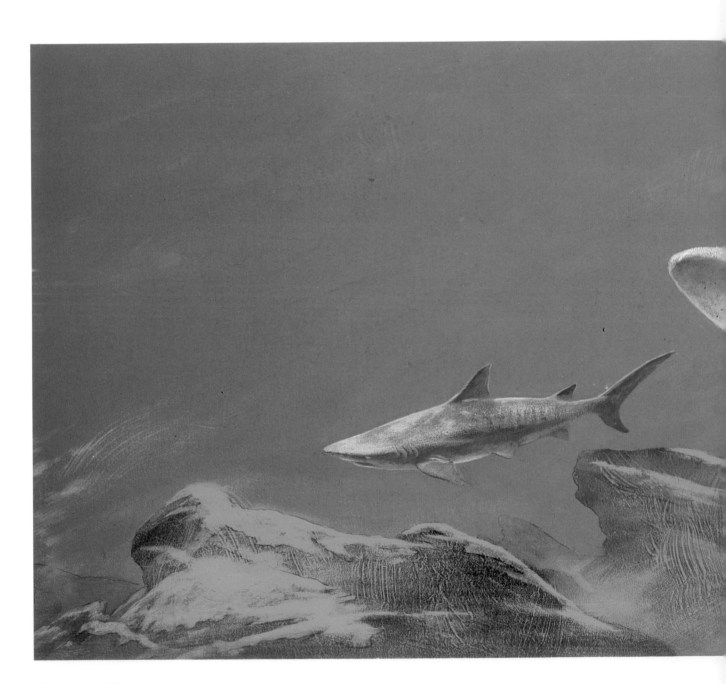

'Even in the earth's own oceans there are quite a few alien looking beasts. In this case sharks. This was done as a portfolio piece and technical exercise, especially in not using the airbrush. I was very pleased with the result.'

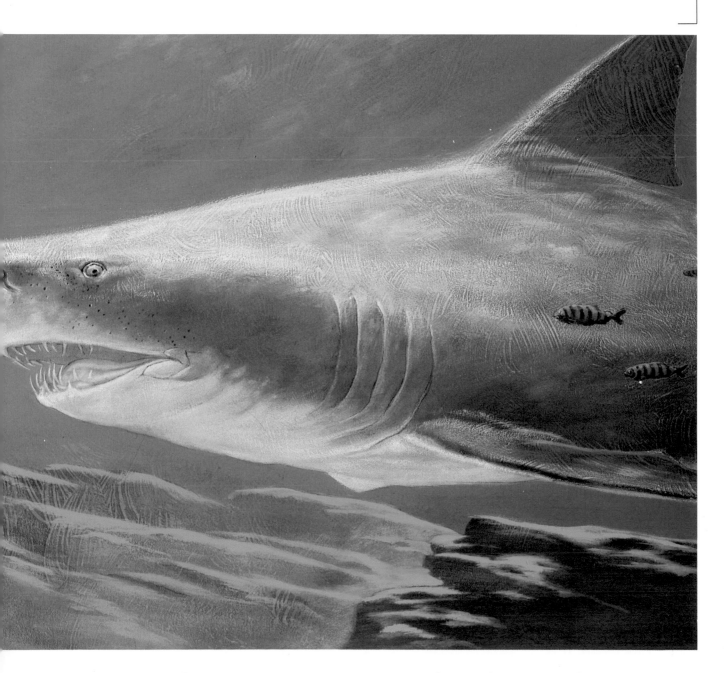

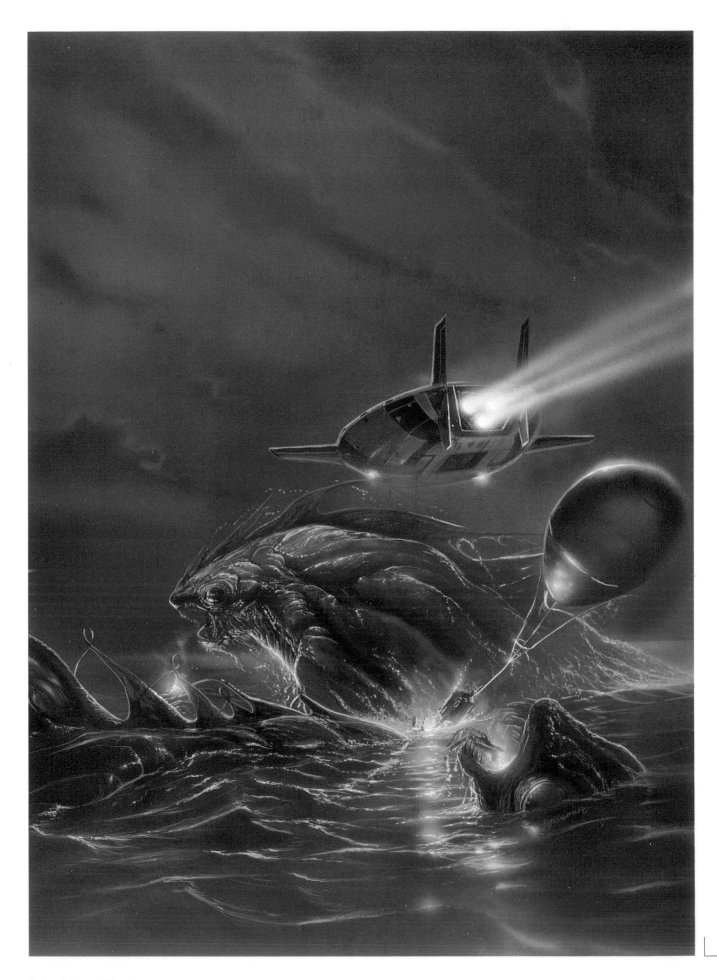

So would he seriously consider swapping two dimensions for three? 'I could eventually, maybe when I'm older. It would be good for keeping flexible. Some say it's not commercial to keep changing what you do but I don't agree. I believe the more variety of media, the more commercial the product will be in the end. But I often have trouble convincing clients of this.'

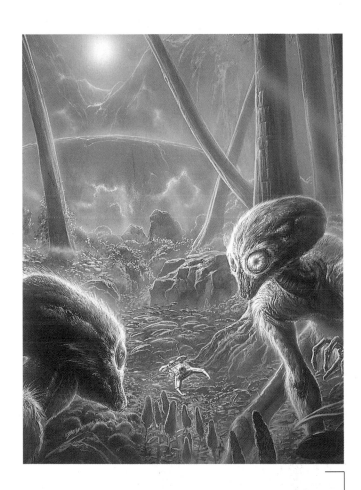

◀ *Waterworld 1993*
Acrylic
13 x 18 in (33 x 46 cm)
Cover illustration,
Analog *magazine*

This piece became the readers' choice for the year. It shows what lies beneath the waves on an alien world orbiting a red giant star. The ocean is in fact acidic and the reaction of any metal that falls into it attracts and excites deep sea life forms into a feeding frenzy. 'An example of where a necessary story element – sparks from an explosion – helped create really interesting light effects, which I desperately needed.'

Primitive Aliens 1993 ▲
Acrylic
14 x 17 in (36 x 43 cm)
Interior illustration,
Amazing Stories *magazine*

Based on a story by George Zebrowski. These insectoid-mammalian creatures inhabit a jungly world which humans would like to settle, even if it means pushing these developing creatures off their own world. That is, if they and their probe escape being taken for a tasty beetle.

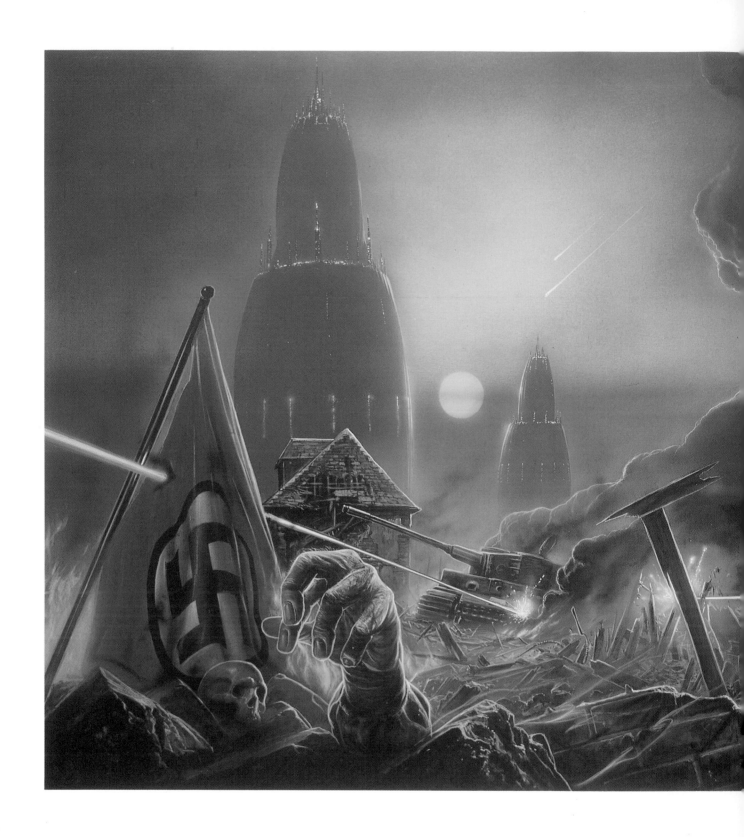

The 1980 World Science Fiction Convention was a turning point
for Bob, and his work was soon in demand, mainly for magazine
illustrations, but in 1984 he also began doing book covers. This was
great, but being of a restless disposition he could not help feeling
typecast fairly quickly. 'The idea of being an artist is to constantly

◀ *Into the Balance* 1993
Acrylic
36 x 24 in (91 x 61 cm)
Book cover, Del Rey Books
Author Harry Turtledove

For marketing reasons this image
was reversed on the US edition
of the book without anyone at
the publishers realizing this would
mean the swastika was back to
front. Complaints duly came in.
When Hodder & Stoughton
printed it the right way round
in the UK the response was
much more favourable.

expand and go in different directions. I don't
like being stereotyped, being asked for the same
thing over and over, yet another spaceship in
front of a planet in the sky; being asked for a
new picture just like another one I'd done.

For All Whatkind 1991 ▲
Initial pencil sketch

An idea which could have
been taken in any of a
number of directions.

◄ For All Whatkind 1991
Acrylic
16 x 28 in (41 x 71 cm)
Unpublished

A 'second look' painting in that it is
not immediately obvious that there
is something odd about it. It sprang
from Bob's abiding curiosity about
what the world would have been like
if dinosaurs had not died out but
instead had evolved into what we are.
Would the events of history have
turned out just the same but with
different participants?

I understand this from a commercial point
of view but I felt I had to institute changes.
I wanted to try more organic things.'

Bob began producing portfolio pieces,
pictures of aliens and anything else that
caught his fancy. Spacescapes without any
humans or hardware were one antidote to his
commissioned work. The response to these
experiments was often, 'Don't quit your day
job.' However, work in different fields began
to trickle in. It helped that he was happy to
drop his usual fees quite drastically at times,
just to get the exposure in new areas, 'It was
really difficult switching trades. People kept
calling up, saying, "Oh my God, what're you
doing?" But I just needed to change.'

In the mid 1980s he met and had a long
talk with the late Robert Bloch, one of whose
stores he had illustrated in a very small
horror fanzine. Bloch said, 'You have a knack
with horror. You should pursue it, it might
change your feelings on a lot of other subjects
in a positive way.'

This insight was to prove prophetic because
when Bob returned to science fiction work
after a spell of following this advice, it was
far richer and more individual than before.

▲ *The Right to Arm Bears* 1993
Acrylic
17 x 28 in (43 x 71 cm)
Book cover, Del Rey Books
Author Christopher Rowley

Just one of many possible scenes
from the novel featuring bear-like
aliens with nasty tempers.

Attack of the Genellan
Bird People 1994 ▶
Acrylic
17 x 28 in (43 x 71 cm)
Book cover, Del Rey Books
Author Scott Gier

The first book by this author dealing with
the conflict that follows the human invasion
of a planet whose dominant creatures are
these strange pterosaur-like beings. 'I love pulp
fiction, and the kind of covers spawned by the
golden age of science fiction. This story had
all those elements so I wanted lots of "pulp
and circumstance"! So did the publisher.
The creatures were really fun to paint.'

This spell of immersion in horror is really what moved his career into the fast lane.

1988 was the year when everything seemed to come together for Bob Eggleton and nearly all the paintings in this book date from then on. 'Things really started coming together in 1988. I was very happy with my technique and things got very heavy workwise; loads of stuff coming in, important authors, interesting projects, different genres. Till then my output had been almost entirely science fiction, plus some advertising, silly stuff like for stereo speakers. Some of it was downright humiliating. I did it basically for the money but it was also a good way to practise technique at someone else's expense.'

Although a great believer in the commercial aspect of his work, i.e. that a good book cover should encourage or even compel browsers to buy the book, advertising as such leaves Bob cold. So it was a relief when real work pushed it aside.

Among other things came a demand for his pictures of aliens. Does he actually believe in them, outside of fiction? 'I believe that someday there will be contact with aliens, but not in my lifetime. Arthur C. Clarke said that *Star Trek* was a great TV program but it was more fantasy than fiction. Captain Kirk would have been lucky to meet one alien race in his lifetime, even if he could get around so much.'

There Goes the Neighbourhood 1993 ▶
Acrylic
14 x 17 in (36 x 43 cm)
Book cover, Easton Press
Author Charles Pelligrino

'You'd be saying this too if you were these Alpha Centaurean aliens and you saw the arrival of a ship from earth. There was only a vague description of these aliens in the book, *Flying to Valhalla*, and no mention of ears. After talking to the author I added them to show emotions. Pelligrino liked them so much he wrote them into the sequel. He also bought this painting.

▲ *Stranger Suns 1989*
Acrylic
18 x 24 in (46 x 61 cm)
Cover, Amazing Stories *magazine*

Illustration for a story by George Zebrowski, who
Bob describes as 'An artist's writer, so visual that
even a short story can give you too many ideas to
choose from. In this case I went for the docking of
an alien spacecraft (the blue sphere) while in orbit
round a triple sun system. One sun has become a
Black Hole sucking matter down into it. The
tractor beam operating on the spacecraft is a relic
of the technology of long extinct aliens.'

Soon Comes Night 1994 ▶
Acrylic
18 x 13 in (46 x 33 cm)
Cover, Isaac Asimov's
Science Fiction Magazine

Giant mechanical beings envisioned by
author Gregory Benford are seen here doing
battle and provoking a storm in which
space and time are falling apart. The
witnesses are less human than they seem
and their planet lies in a gravitational
gulf between two black holes.

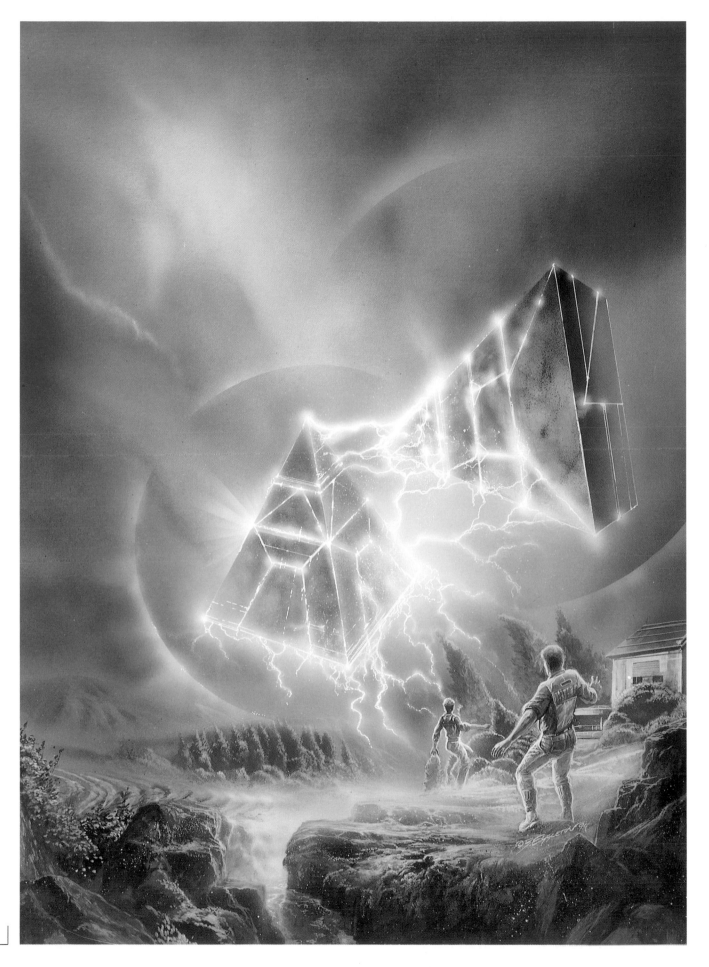

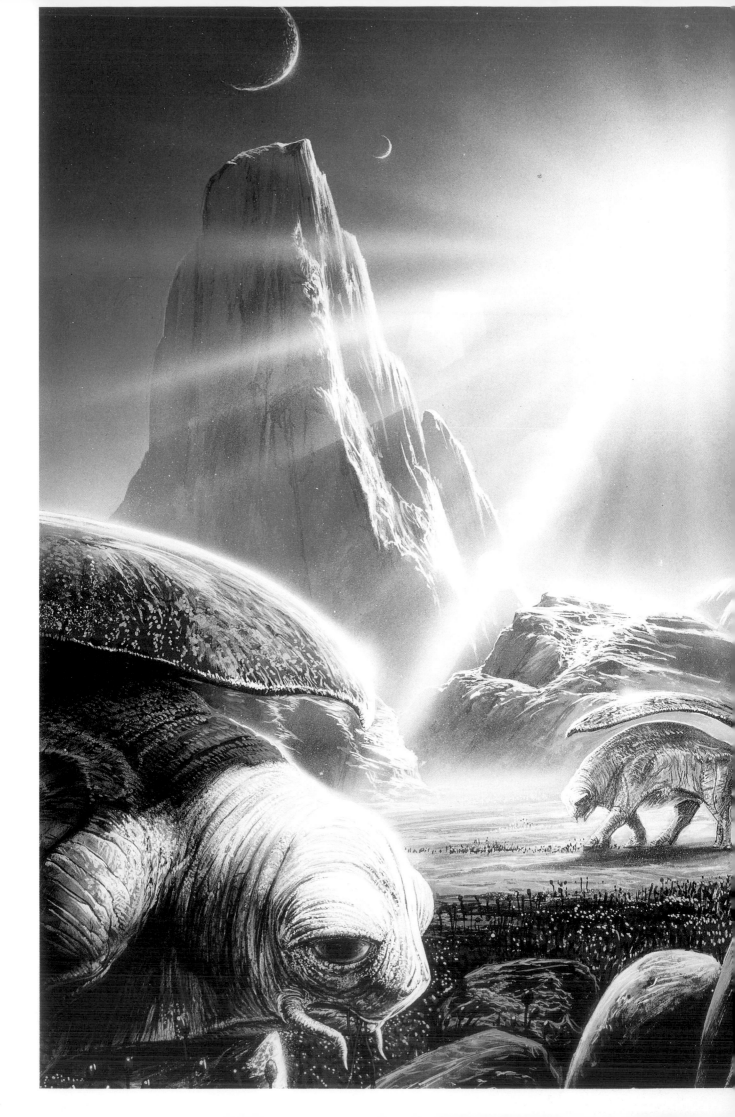

So what about UFOs and, say, the Roswell Incident (the recurring allegations that the US Air Force captured a crashed flying saucer complete with alien crew in the New Mexican desert in 1947)?

'I'm open minded but sceptical. There are UFOs but whether they are alien craft is debatable. As for the Roswell thing, one explanation I've heard is that it was a bunch of apes from an early space shot. You can see why the Government wouldn't want to boast about it. Also I find the description of aliens from believers disappointing. I prefer them in fiction.'

At conventions he is sometimes asked how he achieves the 'realism' of his own fictional aliens. 'My advice to artists is always, if you want to do really convincing aliens, you

◀ *Altair IV Aliens* 1993
Acrylic
14 x 17 in (36 x 43 cm)
Interior Illustration, Astronomy *magazine*

'Believe it or not, this was art for a science fact magazine dealing with life evolving under other suns. In this case the hot blue star Altair IV, which would give out so much light and radiation that any creatures would need polarized eyes and very thick skins. The heat-shield tails were my own idea.'

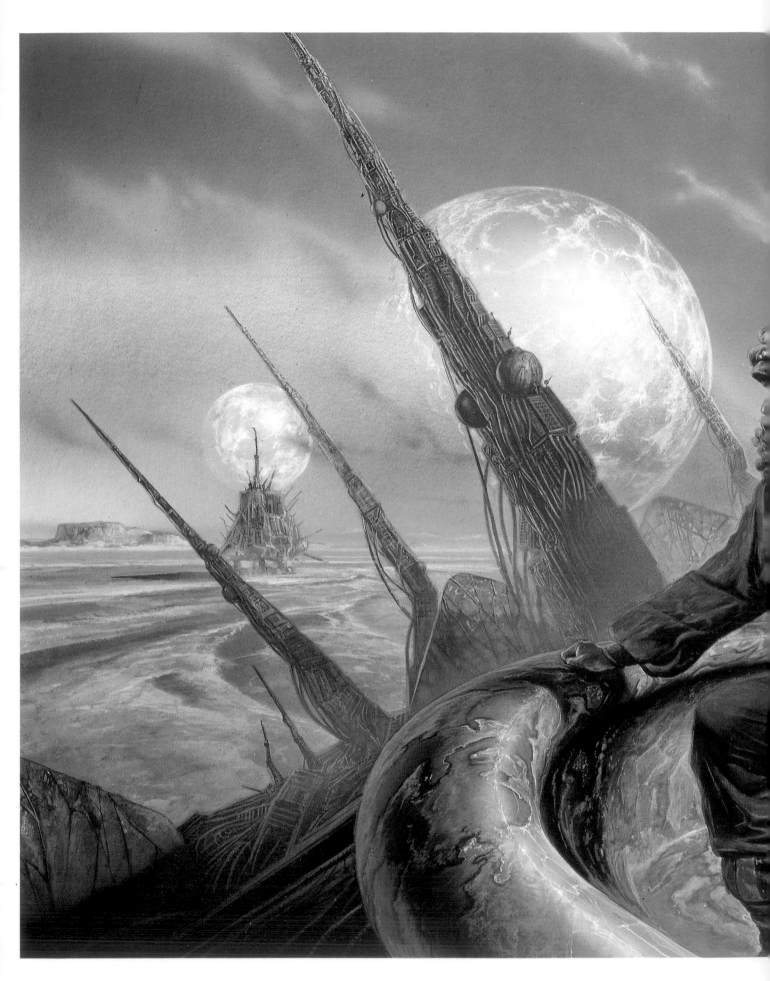

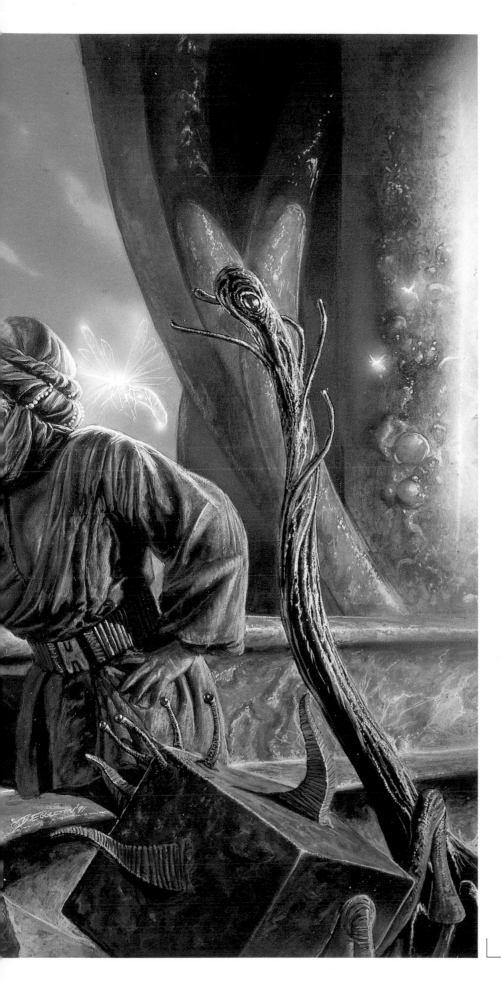

◄ *Strength of Stones 1991*
Acrylic
28 x 21 in (71 x 53 cm)
Book cover, Warner Books
Author Greg Bear

Originally intended as a wraparound
cover, this image appeared in its
entirety on the front, little bigger
than a postage stamp. The model for
the main figure was science fiction
author C.J. Cherryh, on whom the
character in the story was based. She
is standing on one of the living cities
of this planet; vast sentient beings (or
agglomerations of beings) that think,
breathe and can even get up and
move to a new location when it suits
them. Humans live on them rather
like fleas on the back of a dog.

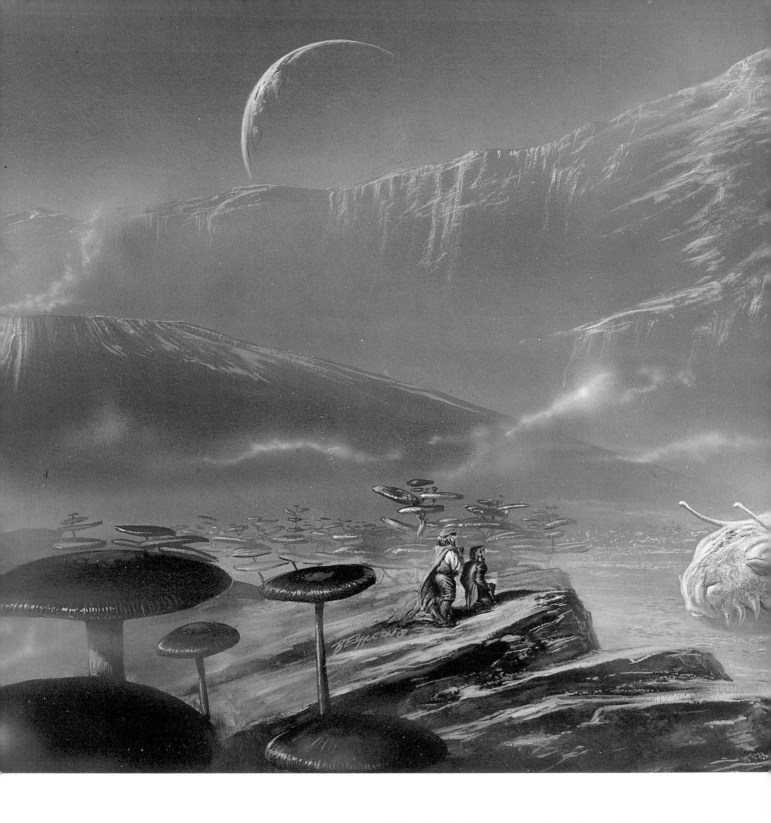

must acquaint yourself with life forms on this planet first, it'll make your aliens all the more believable.' Bob Eggleton's favourite book at the age of 6 was H.G. Wells' *First Men In The Moon* and he has held it very near and dear ever since, despite the fact that most of the science in the story has long since been discredited. 'It remains real in my head. Its unreality somehow does not dim my inner vision of the story

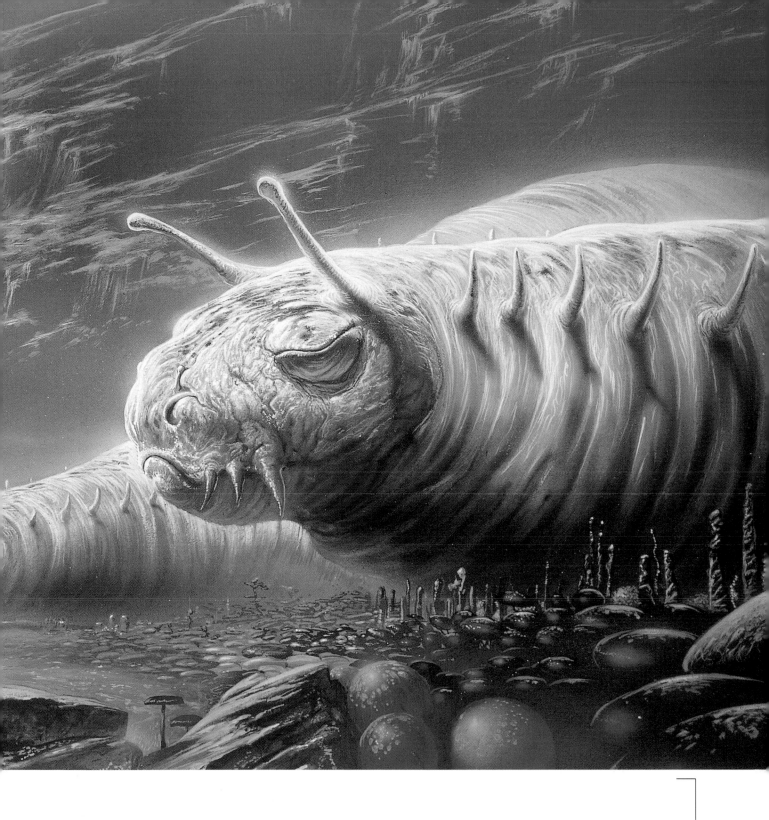

Mooncalf Pastures 1989 ▲
Acrylic
27 x 13 in (69 x 33 cm)
From H.G. Wells' First Men In
The Moon, *Donning Books*

A form of life which grazes on the
moon's surface, which Wells envisaged
as covered in various fungi.

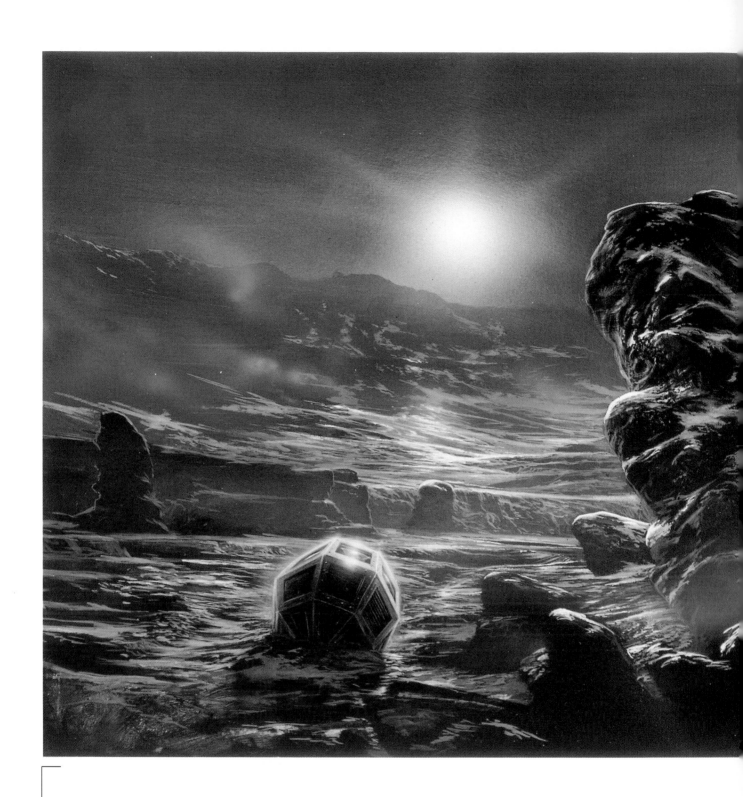

Moon Landing (c. 1899) 1989 ▲
Acrylic
27 x 13 in (69 x 33 cm)
From H.G. Wells' First Men
In The Moon, *Donning Books*

The intriguing thing for Bob while
painting this and the other moonscapes
in the set, was comparing the misty,
strange, alien world he was creating
with the reality we know today.

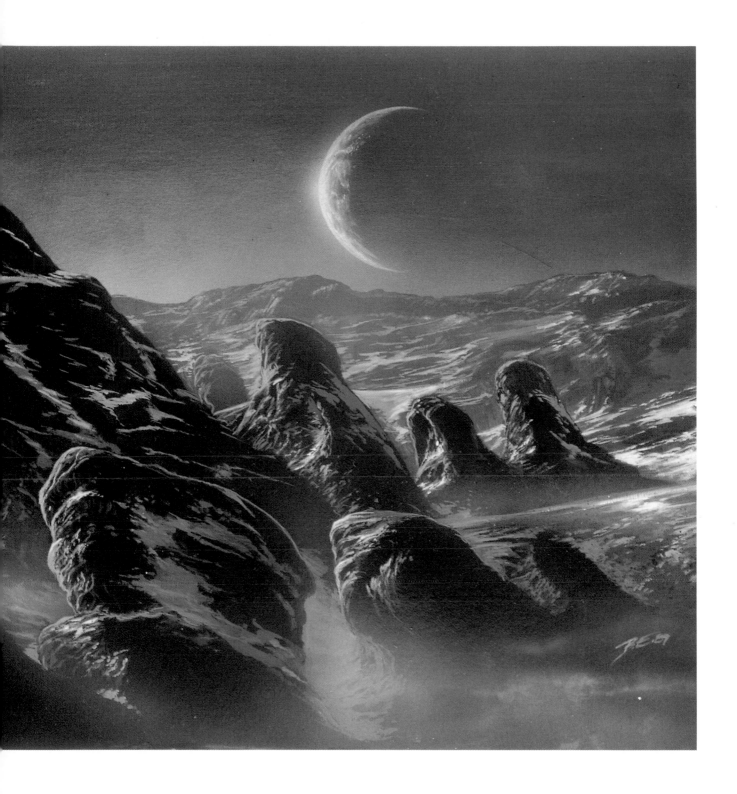

because it's sort of held together by some inner logic like a scientific fairytale. It's a very visual book and when this chance came to illustrate it I leaped at it and had a lot of fun. Unfortunately the book didn't receive very good distribution and the publishers are now defunct anyway. But here are a few of the thirty or so paintings I did for your perusal and enjoyment.'

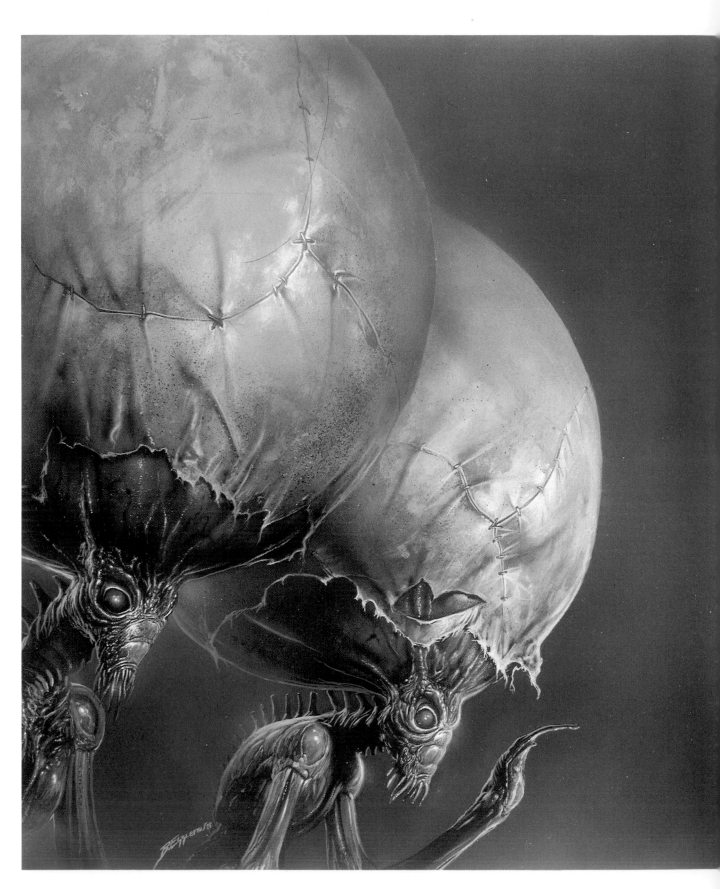

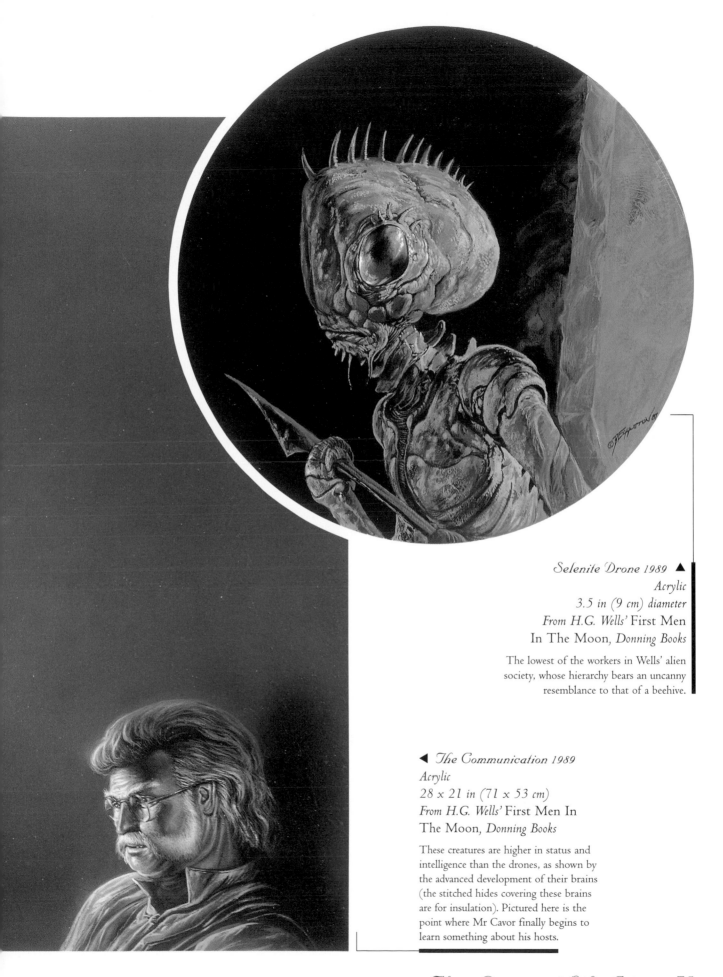

Selenite Drone 1989 ▲
Acrylic
3.5 in (9 cm) diameter
From H.G. Wells' First Men
In The Moon, *Donning Books*

The lowest of the workers in Wells' alien
society, whose hierarchy bears an uncanny
resemblance to that of a beehive.

◀ *The Communication 1989*
Acrylic
28 x 21 in (71 x 53 cm)
From H.G. Wells' First Men In
The Moon, *Donning Books*

These creatures are higher in status and
intelligence than the drones, as shown by
the advanced development of their brains
(the stitched hides covering these brains
are for insulation). Pictured here is the
point where Mr Cavor finally begins to
learn something about his hosts.

The Grand Lunar 1989 ▶
Acrylic
28 x 21 in (71 x 53 cm)
From H.G. Wells' First Men In
The Moon, *Donning Books*

Here Cavor comes face to face (using
the term loosely) with the supreme
ruler of the Selenites, who can read
his thoughts and whose brain
capacity is so vast that the rest of his
body has withered away. Drone
workers act as his arms and legs.

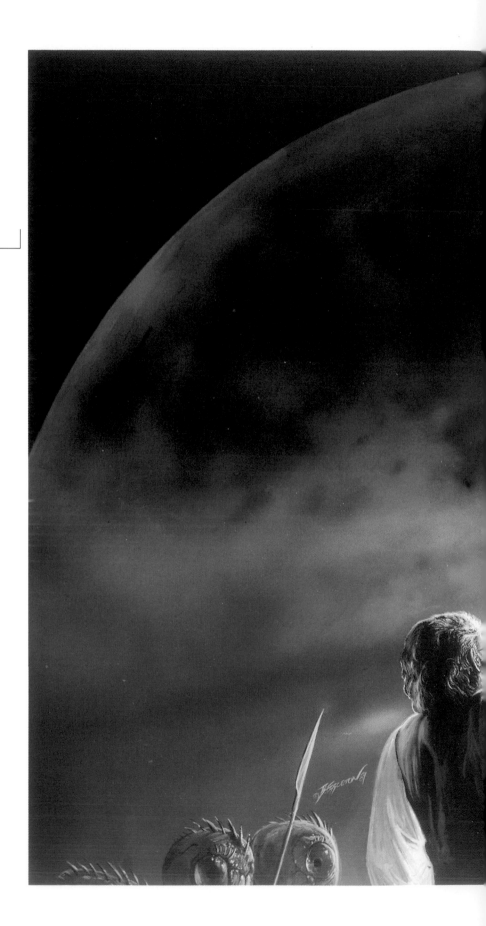

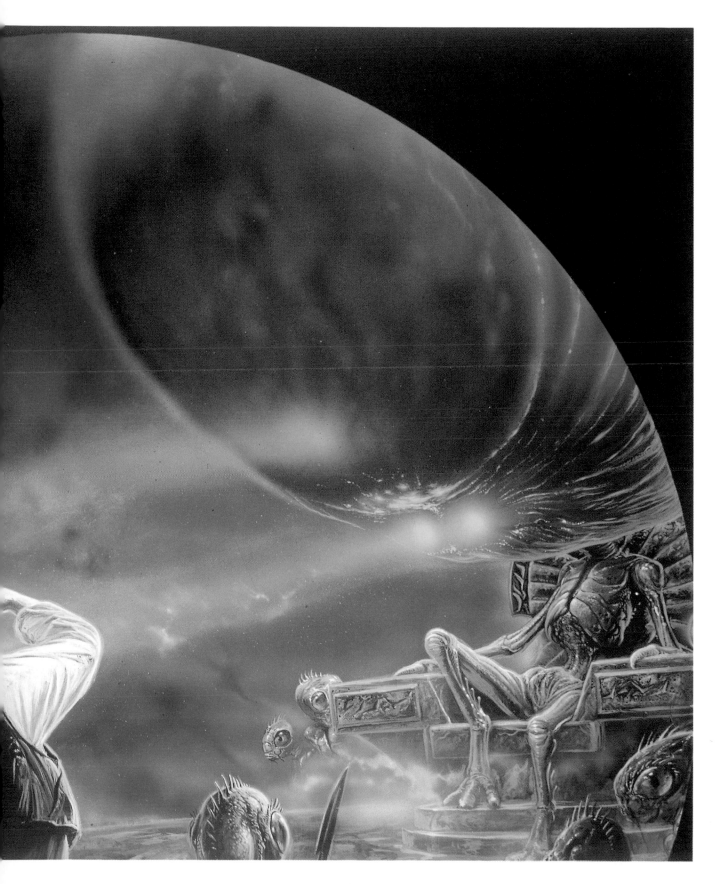

Queen of Angels (2) 1994 ▼
Acrylic
30 x 20 in (76 x 51 cm)
Book cover, Warner Books
Author Greg Bear

'I would have liked to concentrate on
the human aspect of this story but the
publishers went for the hi-tech angle.
It was a challenge to indicate speed
and movement and I particularly like
the colour scheme that emerged.'

Techno Dreams

When faced with illustrating near-future technology, Bob gets uncomfortable. 'You only have to look at painted spaceships of the 1950s, sleek aerodynamic things, and compare them with the real cubed-off ones that went to the moon, to realize how wrong people can be.

'Trying to guess the technology of even fifty years into the future is laying yourself open to being proved wrong pretty soon. I prefer things set so far in the future and so far away that no-one can criticize my designs on the grounds of functionality. Alien technology is better still. I would love the chance to design aliens and their cultures for a movie, like H.R. Gieger. His work really does it for me, it's been a great influence. Not stylistically, but his erotic symbolism, his use of symmetry and stuff like that I really admire.'

In everyday life Bob appreciates technology but falls well short of being a gadget freak. 'I think gadget freaks are too overly optimistic, like some science fiction writers. They think all problems can be solved with the right machinery. Gadgets always claim to make life simpler but somehow it only seems to get more complex. Anyway, I have trouble operating even a fax machine, and for me a car is just a means of getting from A to B. In theory I appreciate sophisticated cars and

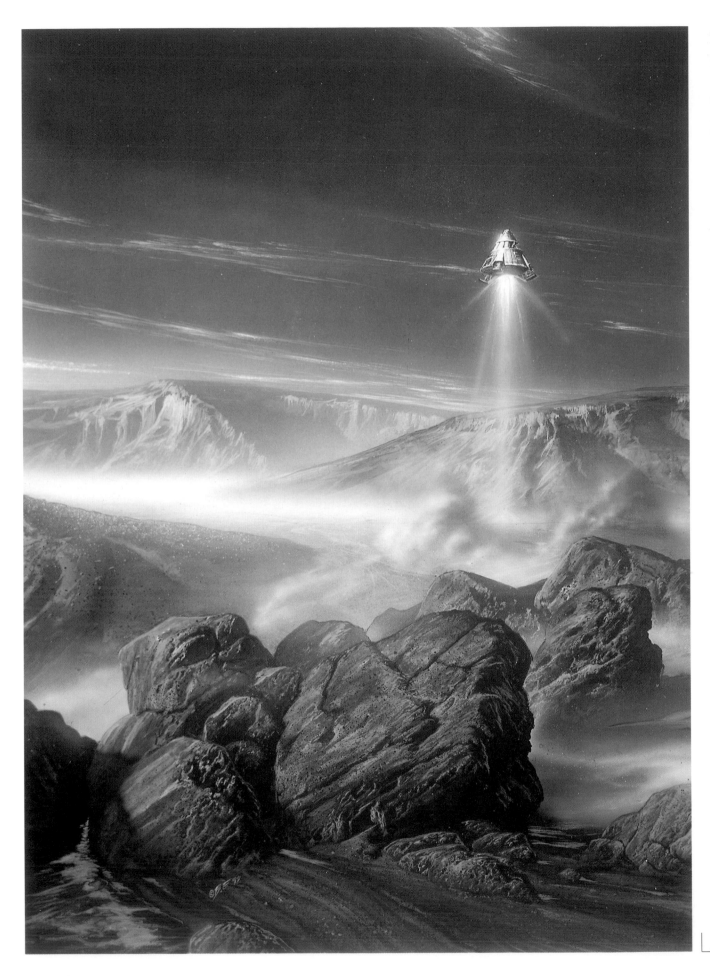

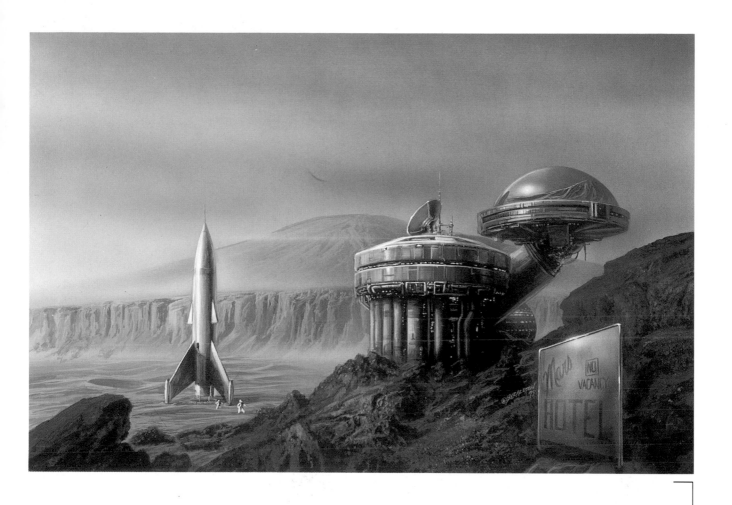

◀ *Martian Landing 1992*
Acrylic
14 x 17 in (36 x 43 cm)
Interior, Amazing Stories *magazine*

Based on a Ben Bova novel called *Mars*.
Most of this picture was painted with
entirely another end in mind but somehow
the top half of the picture would not take
shape. It sat around gathering dust for a
while until Bob read this story and realized
he had already half illustrated it. Adding
the top half came easily and, as with many
of Bob's space pictures, the human presence
is small, indicating that humans are visitors,
not masters, of the universe.

▲ *Mars Hotel 1994*
Acrylic
17 x 11 in (43 x 28 cm)
Book cover, Ace Books
Author Allen Steele

For a short story collection titled *Rude
Astronauts*. 'The publisher was honestly
stuck for an image to go with the title other
than something they couldn't put on the
cover. So I just kind of did something nifty
that paid tribute to Chesley Bonestell's
classic *Exploring Mars* rocket. I love this kind
of spacecraft as I find too many current
ideas overdesigned. We know that while
this is what we "think" will work we're
also pretty sure it won't. So why not have
fun for sheer visual effect?'

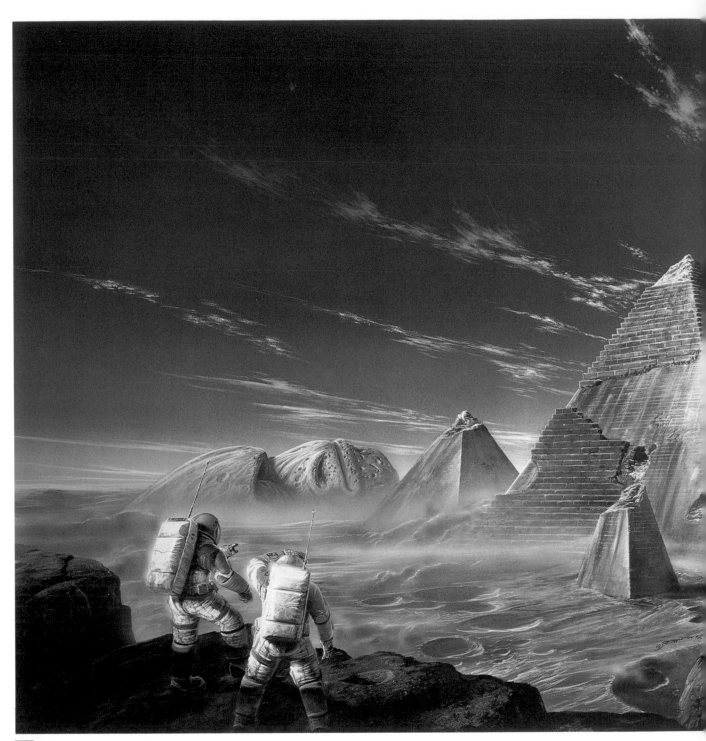

Labyrinth of Night 1992 ▲
Acrylic
40 x 30 in (102 x 76 cm)
Book cover, Ace Books
Author Allen Steele

'I'd always wanted to do a scene involving the alleged "face and pyramid city" on Mars. Many say it's just chance rock forms with odd shadows. Others that it is something far more, as Allen Steele's book suggests. Factually, I find it odd that the space probe, which would have taken more pictures of this area, malfunctioned before it got to Mars.'

would enjoy owning and driving one; but in practice I see them only as targets for thieves.'

Science fiction is where Bob's career began. The trajectory then ran through horror and fantasy, but he is as happy to return to science fiction after a break as he is to leave it when it begins to feel repetitive. 'I would like to keep all the strands of my work going, and open up some new ones. You can only have so many good ideas if you're always working at the same thing. And you have to fight all the time against being pigeonholed, it happens really fast. You break into a new area and if you're not careful you can get stuck there. Already some people see me as a dragon artist, though I've only done a handful.'

Being a commercial artist is itself a kind of pigeonhole in the art world, but it is not a label that troubles him. 'Commercialism for the sake of commercialism is not a sin. What I hate is commercialism packaged as fine art. That's what Abstract Expressionism is about, you're buying into a trend much of the time. There's nothing wrong with any kind of art if the artist believes in what they're doing.

Personally I can accept both abstract and classical work, though there's junk in both. You have to have an open mind, and I consider myself more open-minded than most. Some would say I'm a man of logical contradictions even, as my ideas somehow go in different directions at times.

'In my own fine art I like to suggest an idea or story without spelling it out, so people can make up their own story around the picture. I love hearing reactions. I'm more interested in them than in explaining what I had in mind. When asked questions at a show,

◀ *Griffin's Egg*
Colour Sketch

'This is typically how I submit a colour sketch to the editor and art editor at *Isaac Asimov's Science Fiction Magazine*. Most of the top and left side have to be left open for type. The scene is of astronauts witnessing a nuclear war from the moon.'

Griffin's Egg 1992 ▶
Acrylic
15 x 17 in (38 x 43 cm)
Cover, Isaac Asimov's
Science Fiction Magazine

'Here's the finished article. To emphasize the nuclear explosions I changed the angle of the earth and the lighting on it, but uncharacteristically didn't change anything else much.'

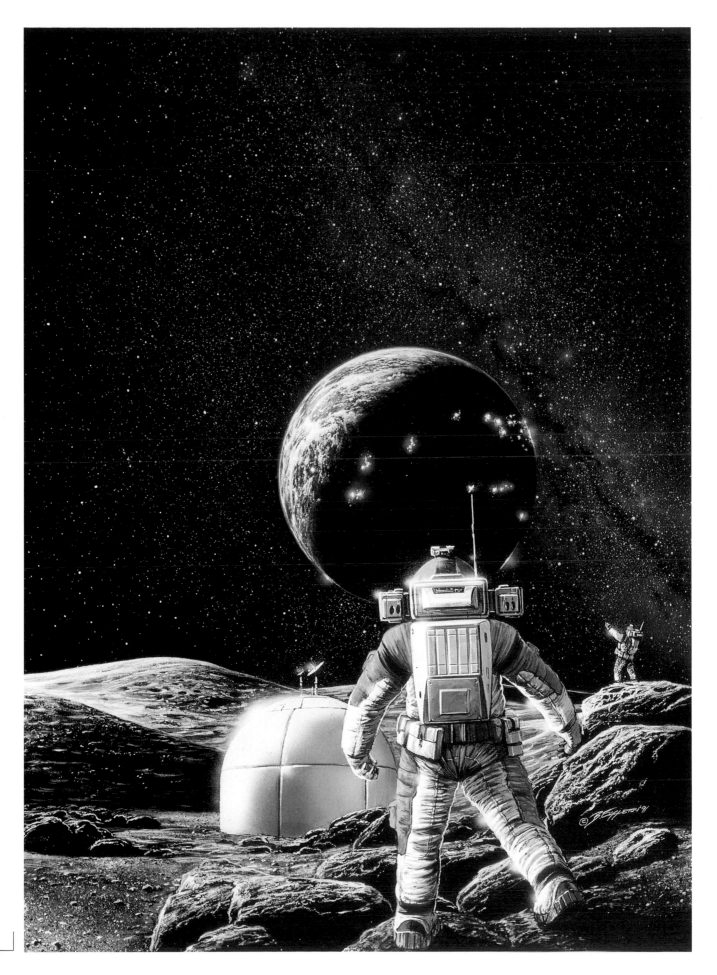

Asimov Chronicles Vol 3 1989 ▶
Acrylic
12 x 9 in (30 x 23 cm)
Anthology cover, Ace Books
Author Isaac Asimov

Part of a larger painting, this was used
for one of a set of six collections of
Asimov short stories. No real art
direction was given, Bob was just told
to 'go and do some robots.'

I'll ask questions back. I think it's hoity-toity pretentiousness for an artist to disagree with what the audience sees in a picture. You can't dictate what people should see.'

One of the pleasures of being a professional artist is the flexibility. 'I have a very non-linear lifestyle. There's no fixed routine; excluding the obvious, like eating. You don't have to put on a suit and fill a seat for set periods of time whether or not there's any useful work to be done. And there's no commuting!

Inclement Weather 1994 ▶
Acrylic
16 x 13 in (41 x 33 cm)
Cover, Absolute Magnitude *magazine*

No airbrush was used here as Bob wanted a very painted texture for this Hal Clement (spot the pun) story. It was about astronauts exploring Saturn's fog-shrouded moon, Titan. Some artistic licence was needed because the entire tale took place in a fog bank with the characters unable to see their hands in front of their faces.

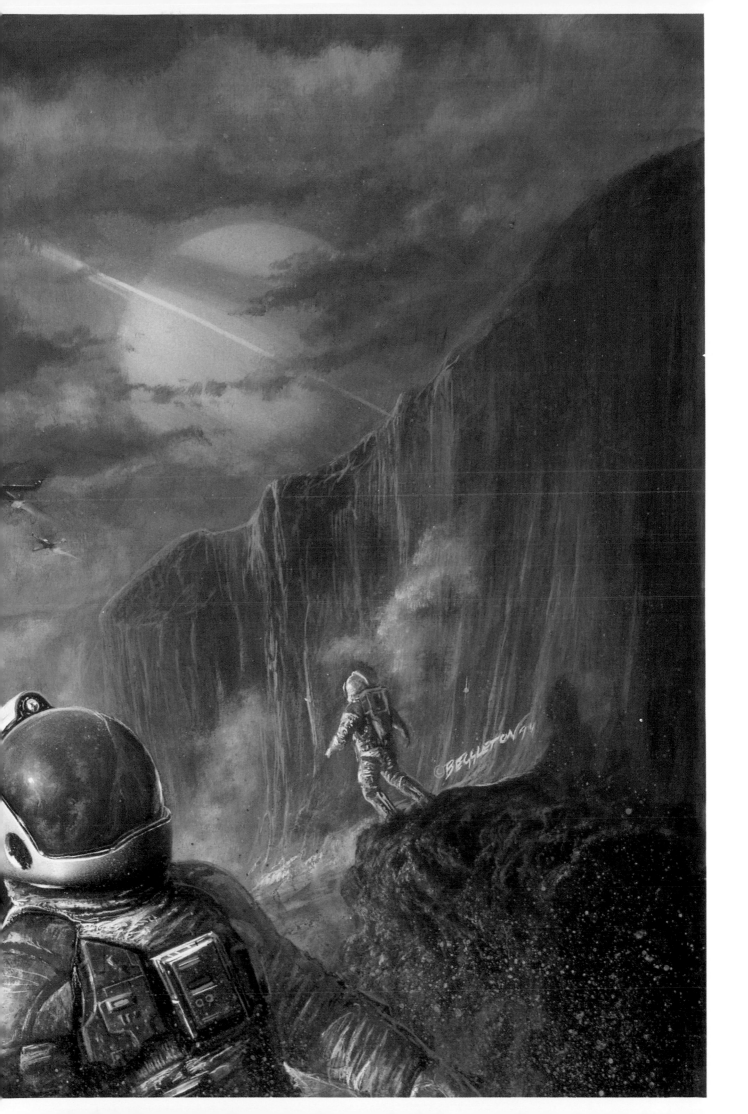

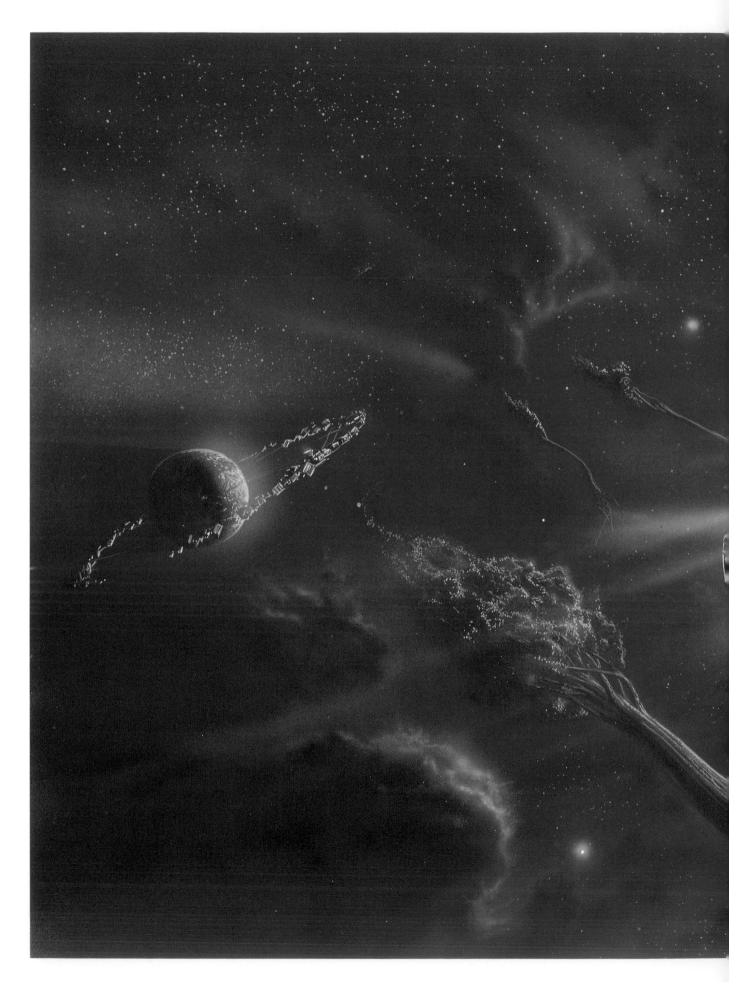

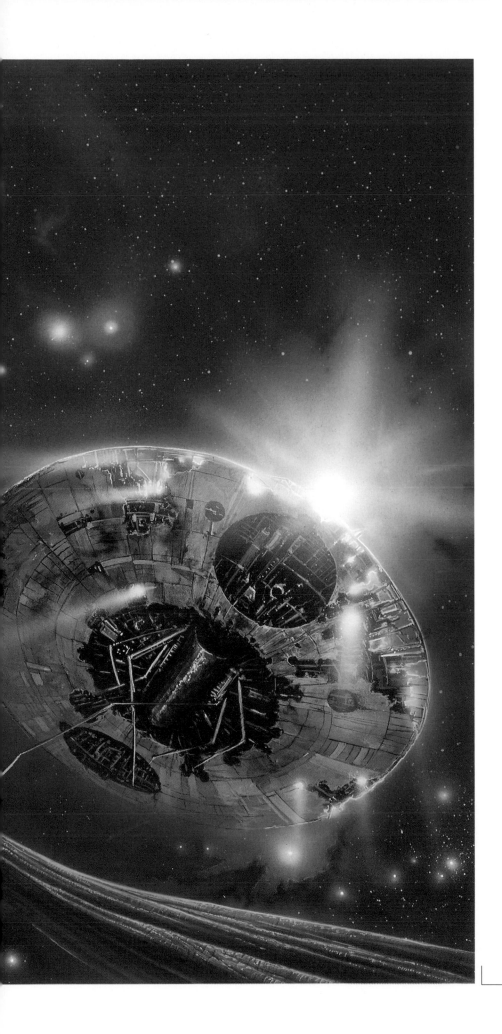

Raft 1990
◀ *Acrylic*
30 x 20 in (76 x 51 cm)
Book cover, Penguin USA
Author Stephen Baxter

'This was for Baxter's first and amazingly complex novel about a private little universe with vastly different physical laws to ours. It shows a wrecked earth-ship trapped ages before. The free-floating descendants of the crew inhabit the place.'

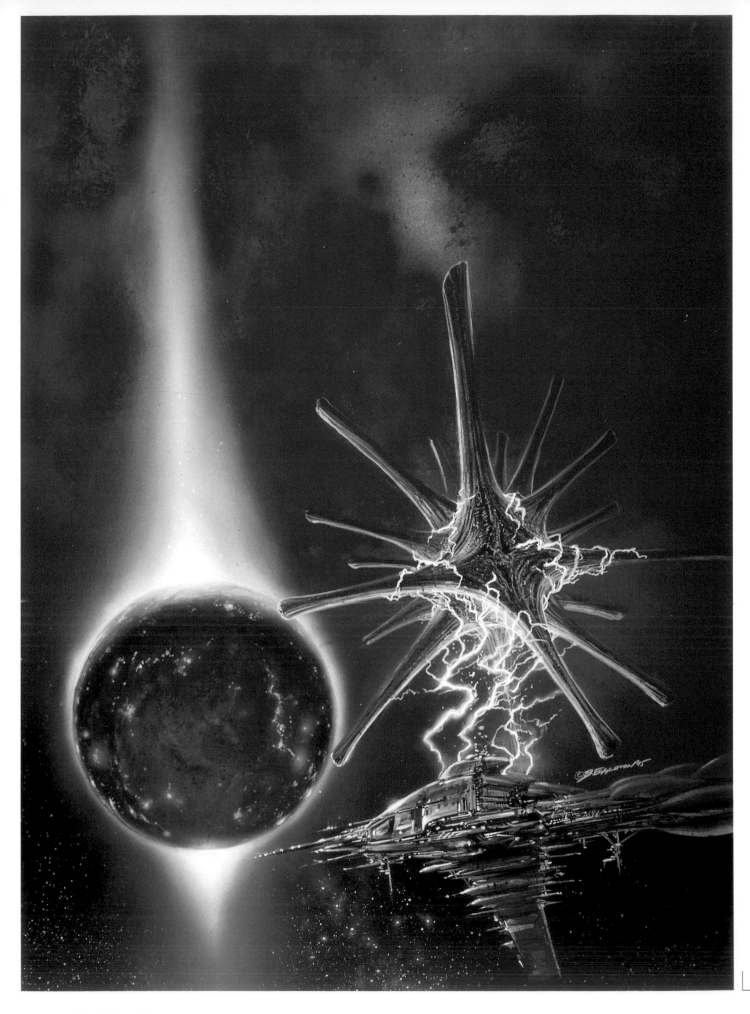

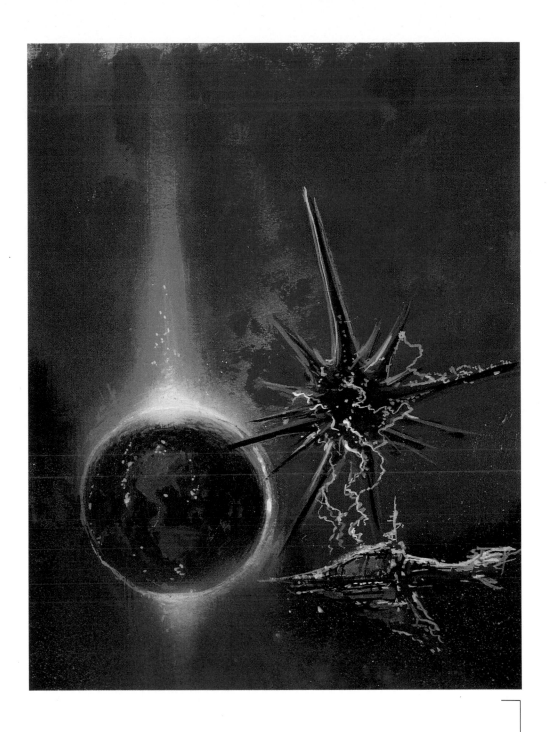

◀ *Earthspore 1995*
Acrylic
20 x 26 in (51 x 66 cm)
Book cover, Tor Books
Editor Gregory Benford

'This was a great piece to do, for a collection
of stories called *Far Futures*. The publishers let
me have a free rein so I went for a purely
compositional and far flung scheme with this
strange haloed planet. Note the land form
vaguely similar to North America. I did some
techie approaches to the earthship at the
bottom that I'd wanted to try for some time.'

▲ *Earthspore 1995*
Colour Sketch

'I stuck closer than usual to this
sketch for the final thing. The
publisher loved it. This evolved
as a paint doodle. I just started
playing with form and ideas and
accidentally came upon this.'

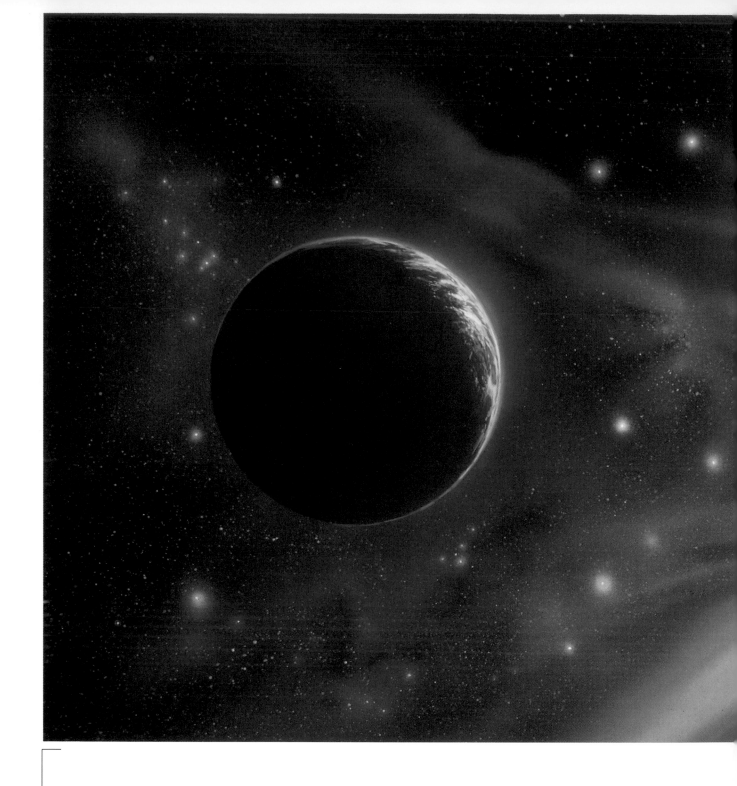

Anti-Ice 1994 ▲
Acrylic
30 x 20 in (76 x 51 cm)
Book cover, Harper Collins (US)
Author Stephen Baxter

For an alternative history book of Earth's space program, set at the end of the nineteenth century in homage to H.G. Wells and Jules Verne. The discovery of a strange element at the South Pole changes the course of history by accelerating the Industrial Revolution and thus the first moon flight. In typical Verne fashion the spaceship is described as 'looking like a silver bullet', but Bob embellished this description and had a lot of fun with it.

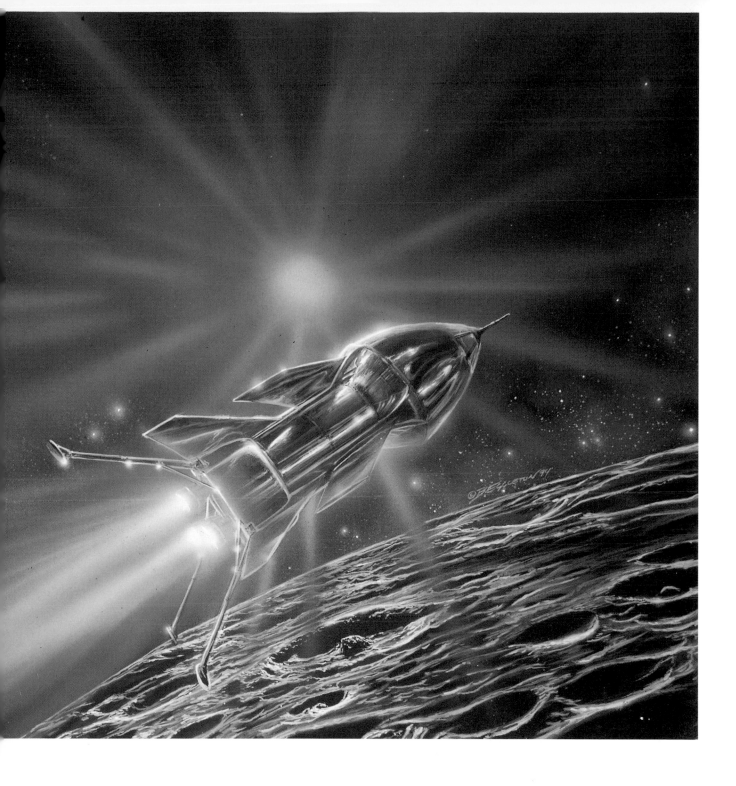

'On the London tube I found it frightening looking at all the
blank faces, people hypnotized into their day-to-day existence
like *The Stepford Wives*. At times like that I often feel like an alien
visitor, having no daily routine myself. I find it amazing to
watch and sometimes think that routine is what makes people
lose their vision. I meet more and more people who say of a
picture, "Gee, I wish I could have done that." I'm sure at one

time they could. Or written a book. But you take certain paths and you're stuck with them.

'The downside of having no routine is that work can get pretty obsessive at times. It doesn't help that my studio is in my home just now. I'm thinking of separating them to get some psychological distance. As it is, when I get obsessed with something it can just go on and on, which can be quite palling at times.'

Does he mind selling his pictures? 'Not at all, as long as I have a good transparency. I do really well through galleries and it clears out the cupboards. If I kept the pictures myself

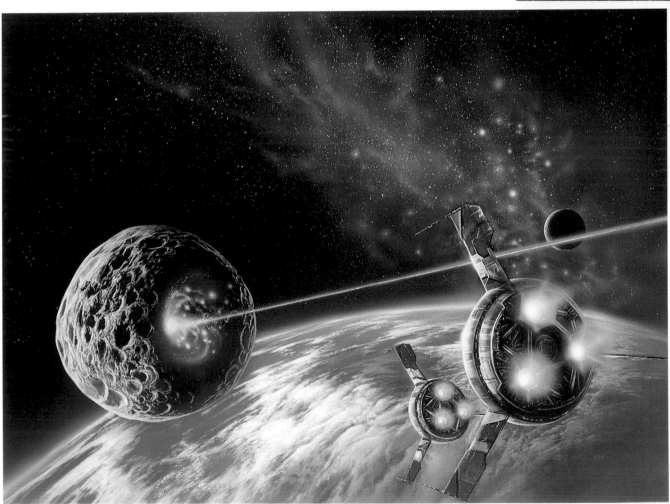

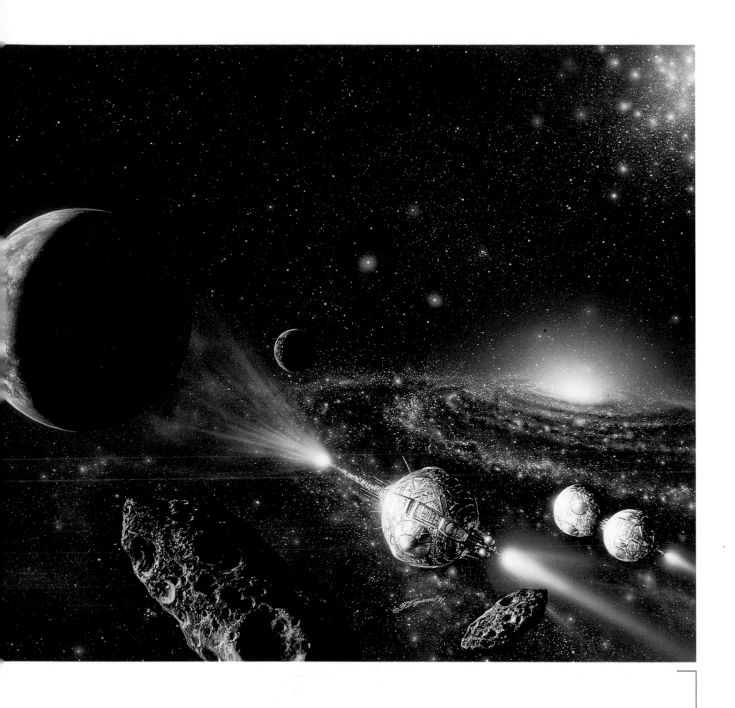

◄ *Eternity 1994*
Acrylic
30 x 20 in (76 x 51 cm)
Book cover, Warner Books
Author Greg Bear

Not so much a scene from
the book as an image to
capture the feel of it.

▲ *The Anvil of Stars 1991*
Acrylic
27 x 18 in (69 x 46 cm)
Book cover, Warner Books
Author Greg Bear

'This was a star-spanning novel with
many, many elements, so the editors
and I felt the best approach was a
vast, sprawling spacescape. The
curious spaceship consisting of three
spheres skewed on a large shaft is
exactly as described. Sometimes
you just have to make the best
of authors' descriptions.'

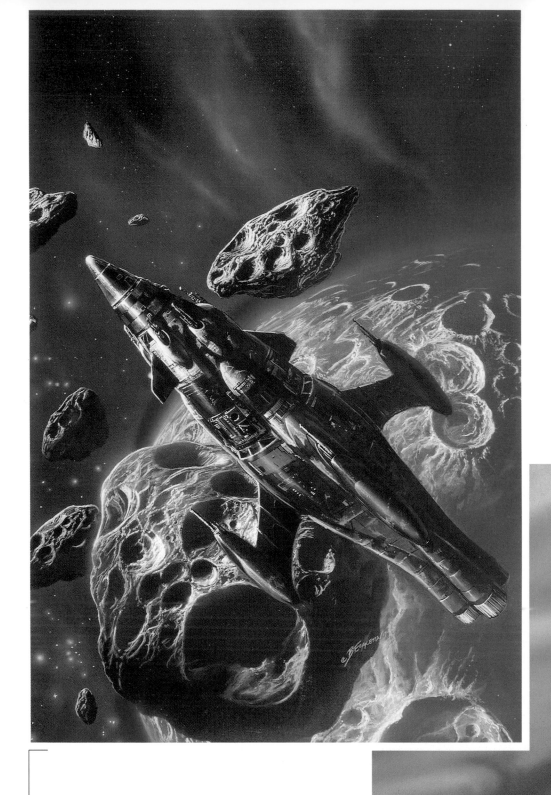

Baroque Spaceship 1993 ▲
Acrylic
15 x 23 in (38 x 58 cm)
Cover for Dealing
in Futures, *Penguin USA*
Author Joe Haldeman

A kind of tribute by Bob to British
spaceship artists like Peter Elson,
Chris Moore and Chris Foss. So
science reality was 'thrown out of
the window and I just went for a
very colourful and busy image.'

they'd just sit in a closet. If someone wants a painting for their living room wall, that's great. It's making someone happy. Sketches are even better and sometimes I'll do smaller paintings than usual for fans on a low budget.'

He also does pretty well out of art prints and trading cards, small packs of assorted images aimed at kids as young as 6 (and not just kids either) who collect and swap them. One company distributes a total of about ninety Eggleton designs in this format and he sees it as a great way of introducing a new

▼ *Rough Weather 1986*
Acrylic
28 x 13 in (71 x 33 cm)
From Visions of Space,
Paper Tiger

A spacecraft in close orbit around Jupiter shields itself from radiation by riding behind Amalthea, the smallest moon. Elaborated from a very blurred Voyager shot.

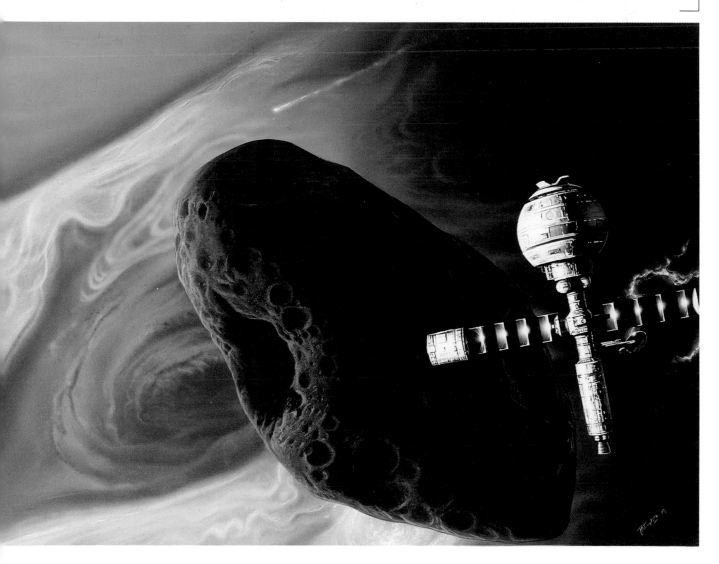

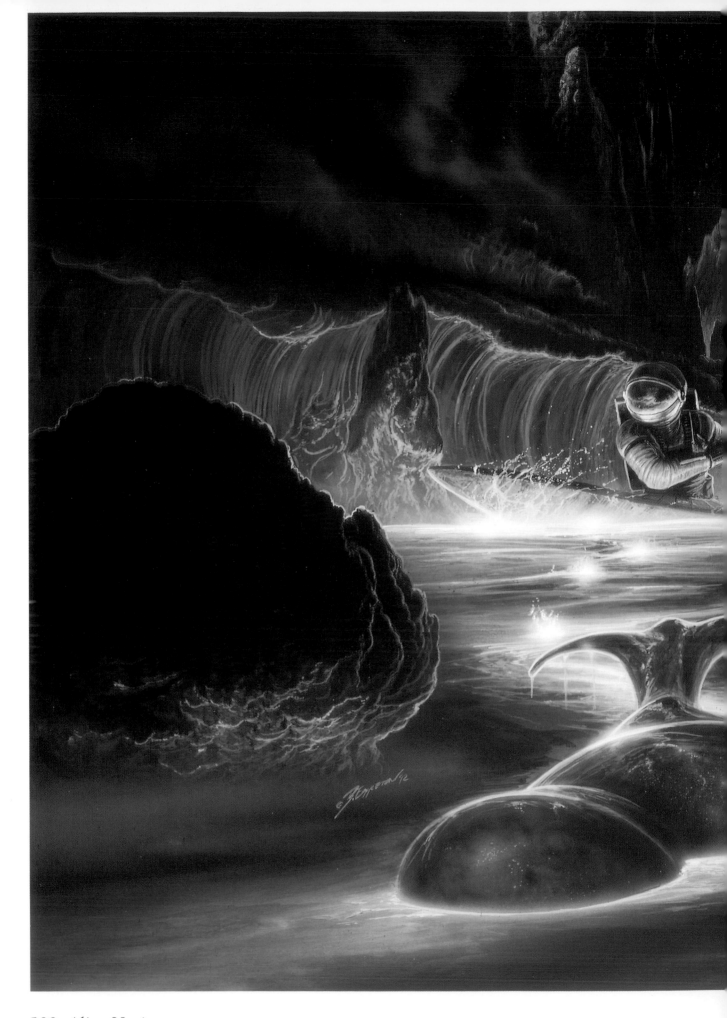

audience to both his own work and fantasy art in general.

Technique is not something Bob particularly cares to enlarge on, partly because he sees little point in it — what works for one artist often fails for another. Also, many of his methods do not succumb easily to step-by-step analysis.

Broadly, though, he uses acrylic paints because he is a 'believer in instant gratification, and the notion of hanging around for weeks waiting for oils to glaze would drive me mad. As it is, with the speed I work I often end up standing around waiting for the acrylics to dry.'

He uses the airbrush for similar reasons of speed, but enjoys any medium suggested or

◀ *Bright River 1992*
Acrylic
14 x 17 in (36 x 43 cm)
Cover, Isaac Asimov's
Science Fiction Magazine

An astronaut kayaking down a river of molten lava on a far-off planet, confident that no life can exist in such hostile conditions, is about to be proved wrong by the mischievous little creature later dubbed a 'rock otter.'

demanded by a subject. Most of the pictures in this collection are straight acrylic paintings with some use of airbrush, but gouache and coloured pencils can also be incorporated. Also, with planetscapes he often uses an unorthodox glazing technique that he invented himself which, so far as it can be explained, seems to involve smudging paint on to the surface with a sponge or anything else that comes to hand, and using the normally opaque acrylics as a translucent base for what follows.

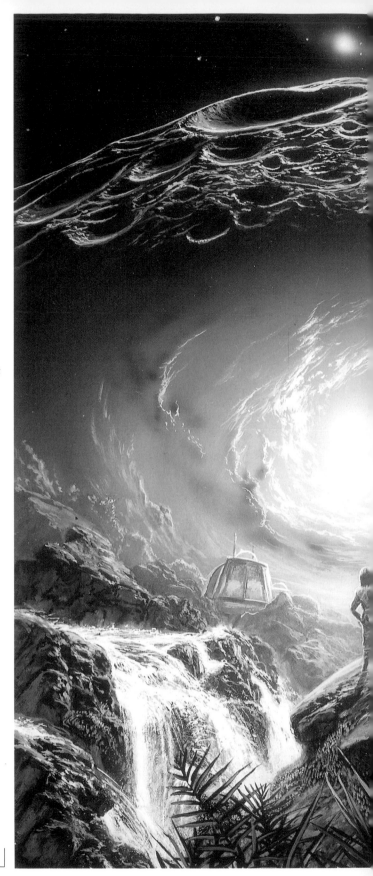

Behind the Stars —
The World Inside 1992 ▶
Acrylic
14 x 17 in (36 x 43 cm)
Cover, Amazing Stories *magazine*

Commissioned as an interior illustration for a George Zebrowski short story, the editor liked it so much he paid extra to use it as a cover. It shows an asteroid beyond the orbit of Pluto made habitable by an internal energy panel which produces all the light and heat of a friendly sun.

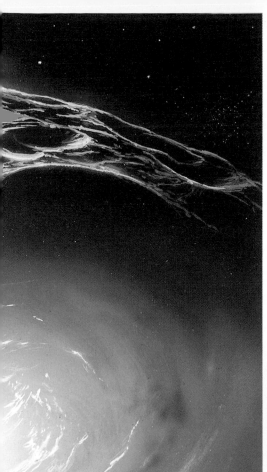

Because it's There —
▼ *Highclimber 1992*
Acrylic
14 x 17 in (36 x 43 cm)
Cover, Analog *magazine*

Analog readers liked this so much they voted it Cover of the Year. The theme is climbing on another planet whose mountains are so high they reach out into space itself. Climbers would need special gear that recycles all their bodily fluids. 'This is what I thought some of that gear might look like. I had great fun designing it and my only doubt about such a suit is — what do you do about an itching nose?'

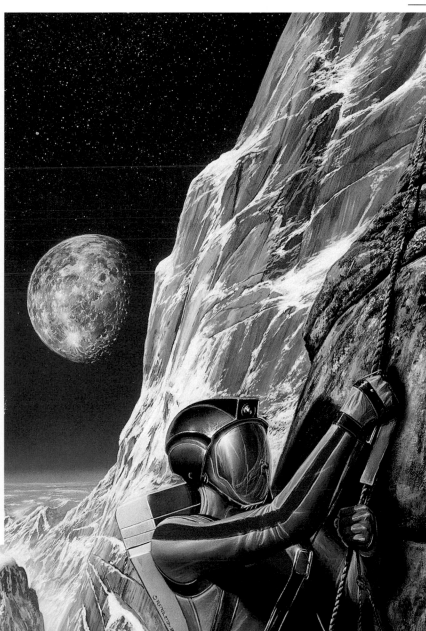

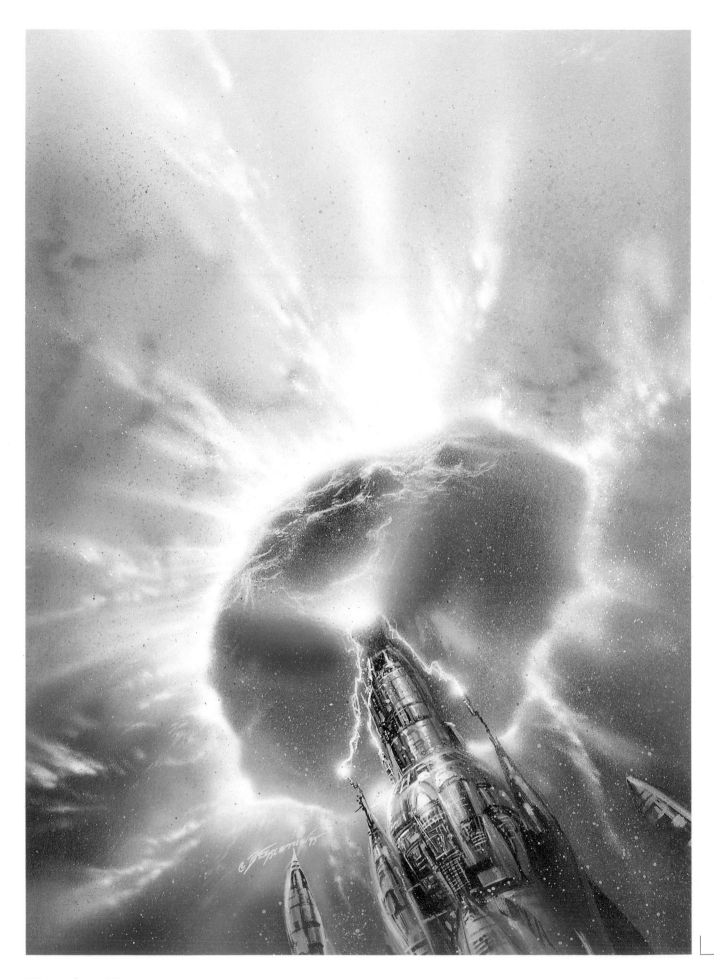

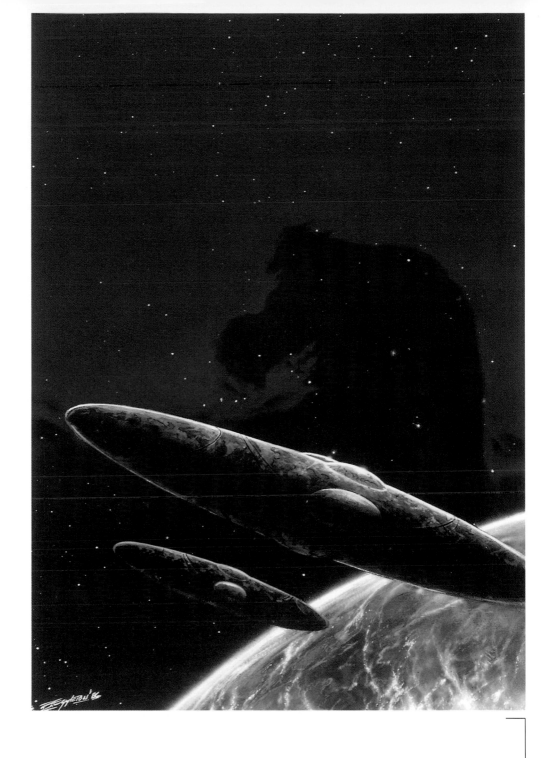

◀ *Death of a Comet 1995*
Acrylic
11 x 17 in (28 x 43 cm)
Cover for The Killing Star,
Easton Press
Authors George Zebrowski
& Charles Pelligrino

This shows the cataclysm of a comet chunk
plunging to fiery extinction in the sun,
observed by the earth-ship in the foreground.
Technically an experiment with a 'more
forensic' style of painting.

▲ *Cigar-Shaped Alien Ships 1985*
Acrylic
14 x 20 in (36 x 51 cm)
Cover, Worlds of If *and* Science
Fiction Chronicle *magazines*

This began as a portfolio piece, a factual
astronomical painting of the Horsehead
Nebula to which the strangely ominous
alien spaceships were later added.

The essential ingredient of his work though, the thing without which all the technique in the world is pointless, is that Bob Eggleton loves doing what he does. And when he does begin to feel jaded with a theme, he drops it until fresh juices of inspiration flow. Not for him the Protestant ethic that work is only meaningful if it hurts. Almost the exact opposite, in fact. Enthusiasm is what gives his pictures their sparkle.

The Mote In God's Eye 1992 ▶
Acrylic
17 x 14 in (43 x 36 cm)
Book Cover, Easton Press
Authors Larry Niven
& Jerry Pournelle

'Once again I wanted to show humanity in this vast empty space. I really like the way the planet turned out.'

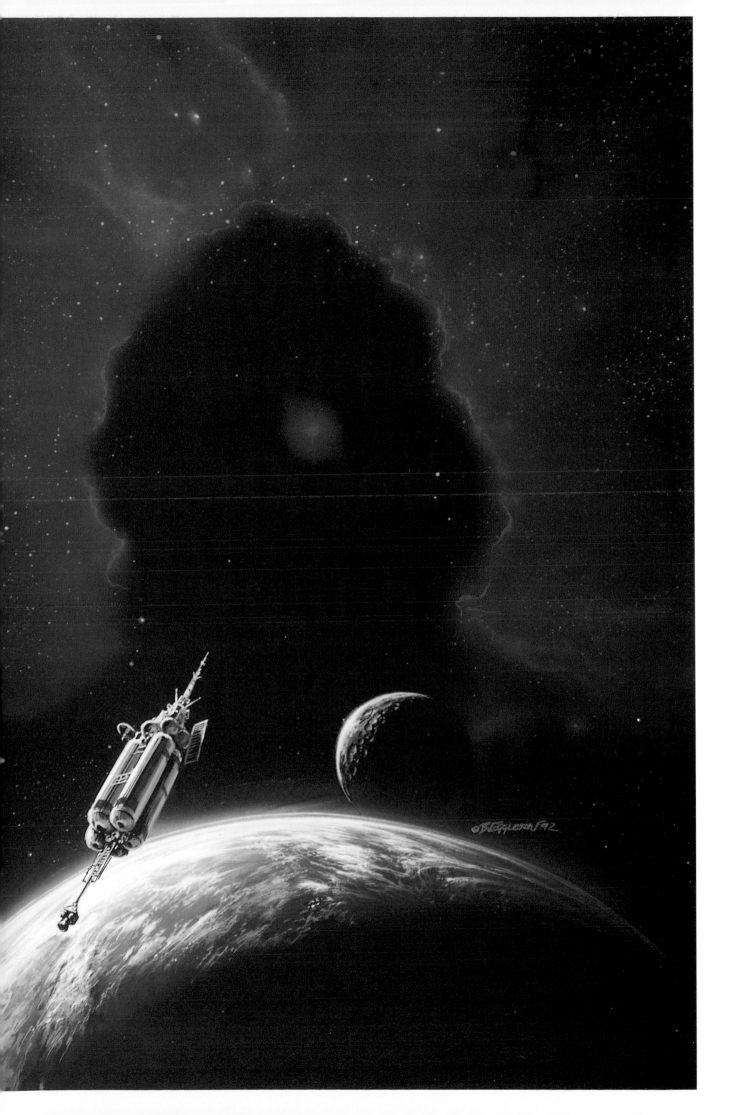

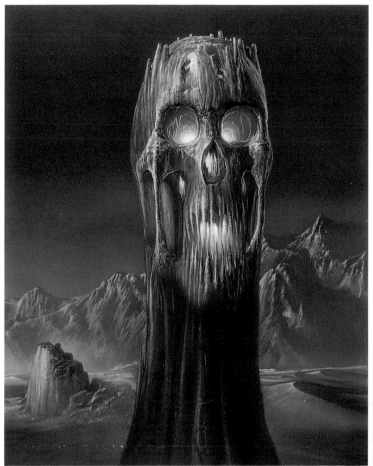

◄ *The Last Aerie 1993*
Acrylic
18 x 16 in (46 x 41 cm)
Book cover, Tor Books
Author Brian Lumley

More adventures on the
vampires' home planet.
Knowing the format this
time, Bob produced a far
more effective cover.

Blood Brothers 1992 ►
Acrylic
30 x 22 in (76 x 56 cm)
Book cover, Tor Books
Author Brian Lumley

This book offers a different perspective
on the Necroscopic universe by taking
the reader to the planet where vampires
originate. A very visual story in Bob's
opinion that Tor wanted to give a
'big book' look while retaining the skull
theme of the earlier covers. This was
achieved by suitably weathering one of
the great rocky stacks where vampires
dwell. Unfortunately plans were changed
and the art was severely reduced and
cropped in the end. It is shown here as
it should have appeared.

... And I Do Have A Dark Side

'**A**s a kid I always loved creating haunted houses, dressing up at Halloween and all that stuff. I also watched all the classic horror films and found them really stimulating. I enjoy a good old-fashioned thrill. I believe each of us has a certain capacity for horror.

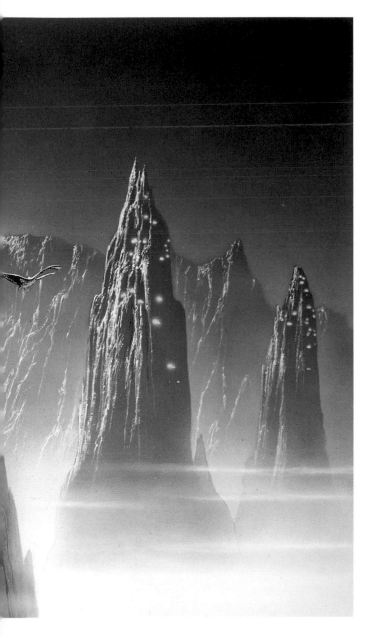

'But for me vampires, werewolves and other such monsters aren't the really frightening things because I know they more than likely don't exist. My own personal, ultimate horror is having control taken away from me. Anything involving plagues, viruses or crippling injury is far more scary. I have a real horror of any sort of hospitalization, but particularly insane asylums and the abuse of psychiatry. Those are the real horrors.

'Maybe it's because I grew up with a few monsters in my own head. You know, I had a lot of stuff to deal with at times and monsters were a way of personifying the problems. And the monsters weren't always on the other side, sometimes they were on mine. Ultimately horror as a genre is just a lot of fun, it's a way of acting things out in the imagination. I find love a lot more scary because you have to expose yourself to feel it,

but you're then vulnerable. Your feelings are in someone else's hands.'

Apart from providing an outlet for his fascination with the bizarre and macabre, horror stories presented Bob with a rapid learning curve in the art of book cover illustration generally, as they demand an even more bold and simple image than usual. In general the line between good and evil is very clearly drawn, there is a very black and white contrast that makes for dramatic paintings.

He is aware that some people, particularly those of a Christian persuasion and including a few friends and relations, will disapprove of the inclusion of these horror pictures with the rest of his work. There is a common view that dabbling with horror fiction is akin to courting the Devil. But to Bob this side of his work is inseparable from the rest. They feed off each other.

Robert Bloch's comment led Bob ultimately to his first commission for a horror cover, and then several more. People's reactions were interesting. A common response to his spacescapes had been that they were 'very nice' (a mixed compliment to pay any artist), but with his horror work it was 'Wow, that's really great!' He also found himself having a lot of laughs.

Bob's work on horror comics led to being commissioned for Brian Lumley's *Necroscope* novels 'which quite literally put me on the horror map. Horror is a far less pretentious field than science fiction tends to be. Science fiction is full of people who are convinced theirs is the way things will happen, that we know everything there is to know.

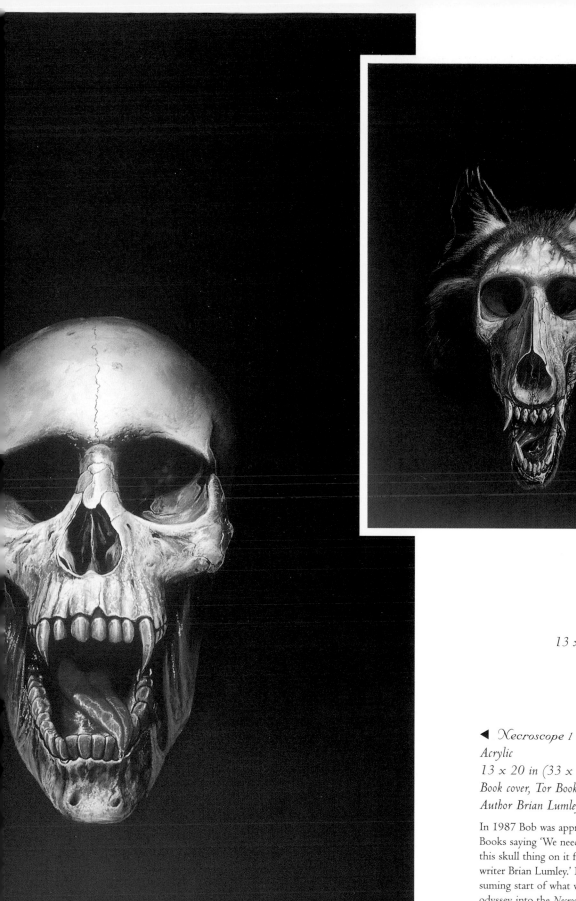

▲ Necroscope 2:
Wamphyri 1988
Acrylic
13 x 20 in (33 x 51 cm)
Book cover, Tor Books
Author Brian Lumley

◄ Necroscope 1 1988
Acrylic
13 x 20 in (33 x 51 cm)
Book cover, Tor Books
Author Brian Lumley

In 1987 Bob was approached by Tor
Books saying 'We need a cover with just
this skull thing on it for British horror
writer Brian Lumley.' It was the unas-
suming start of what was to become an
odyssey into the *Necroscope* world for Bob,
and a bit of a turning point in his career.
The immediate requirement, though, was
for a single telling image that would
capture the overall mood of the book
rather than any specific scene in it.

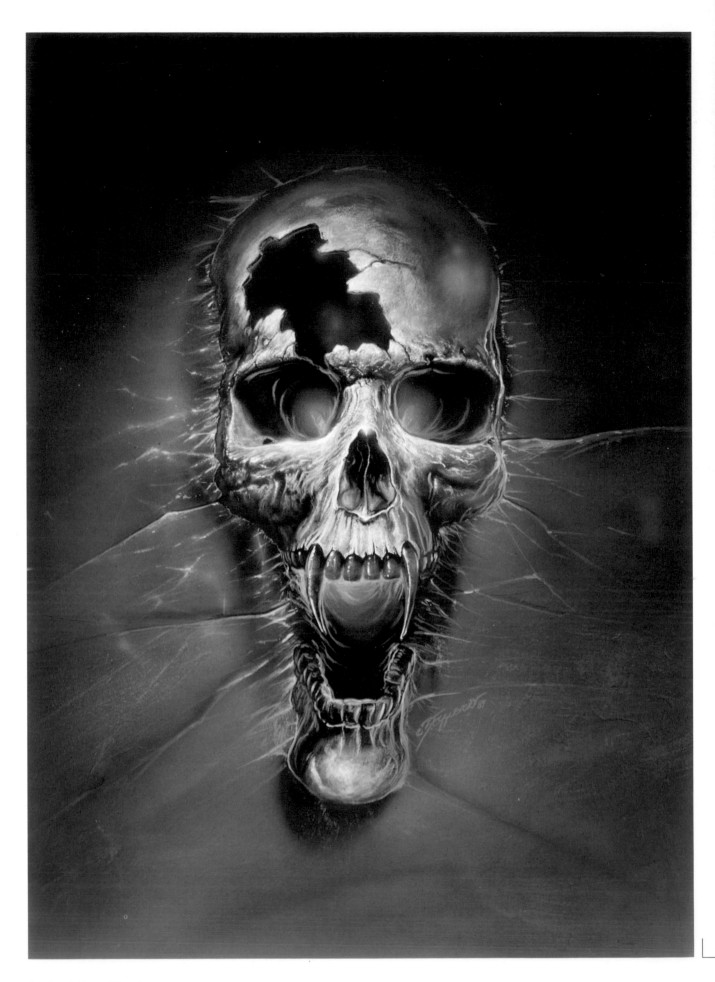

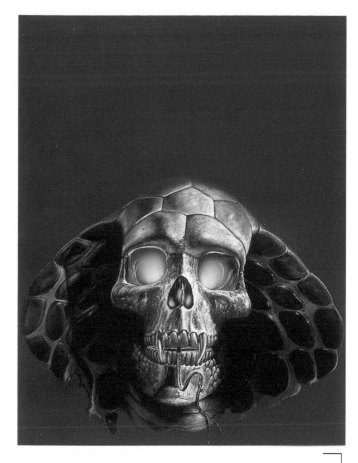

Horror can be more fun and interesting because people have less fixed ideas'.

The *Necroscope* book covers were completed in a very short span of time, by the end of which Bob could draw skulls with his eyes shut, 'Then what I found was that the horror work had somehow changed the science fiction. Many people pointed this out, they weren't sure how, but it had changed my composition in some way. My aliens were creepier, but there was also some overall change, compositions were simpler, and the colours really seemed far better.'

Some of the improvements to the science fiction work came simply from putting it on the backburner for a while and then being able to consider it with fresh eyes on the return. It was easier to see what Bob had been trying to do and where he had been failing. His ideas on the subject came into focus and the work became 'less intense but more powerful'.

Perhaps the boost to his confidence also helped because the *Necroscope* books were incredibly successful and Bob's covers were 'Served up in airports across the country. Everybody had seen them. Some people were stunned to learn that the Bob Eggleton who did fantasy had also done these other covers

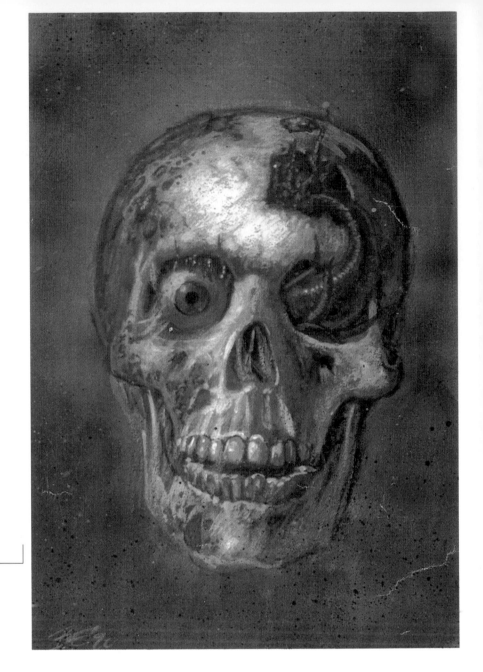

Fruiting Bodies/
Fungusface 1992 ▶
Sketch

In many ways Bob preferred
this sketch to the finished picture
because of its spontaneity.
He was asked to remove the
glaring eyeball, though.

they knew. They'd say, "Wow, my wife's read those books." Even people who never read horror recognized the covers.'

Although he disagrees with people who equate an interest in horror with evil, Bob has not been without qualms himself. When the first rush of horror work came, to the exclusion of all else, he did find himself thinking dark thoughts. Because of a balance problem, he became convinced for a while

Fruiting Bodies/
Fungusface 1992 ▶
Acrylic
11 x 14 in (28 x 36 cm)
Book cover, Tor Books
Author Brian Lumley

The final touches of this skull
were achieved by a study of assorted
slimy moulds and toadstools.

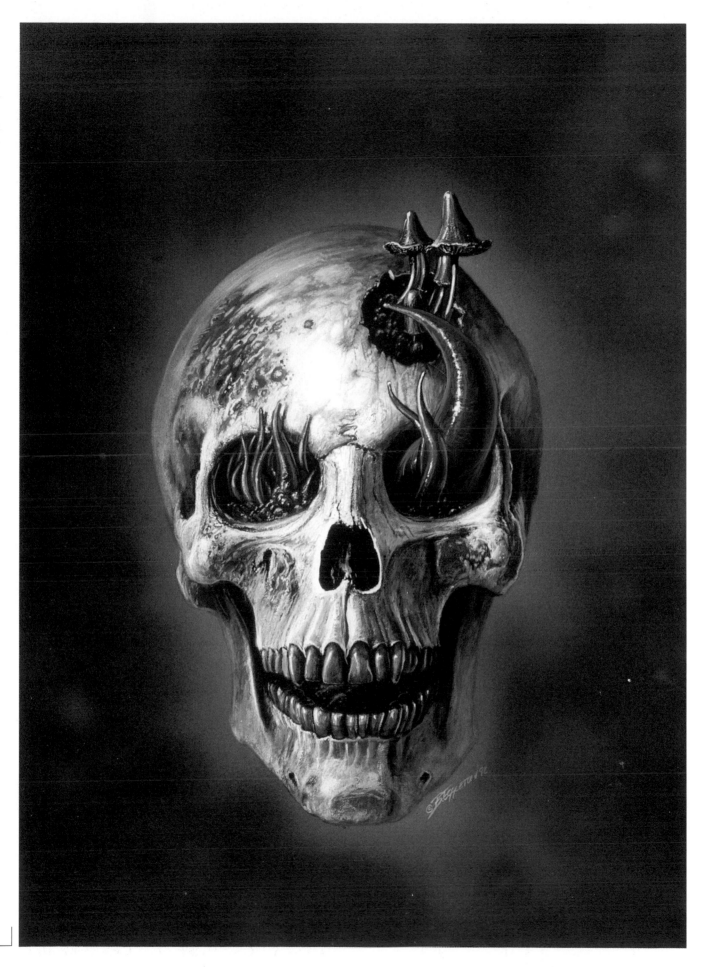

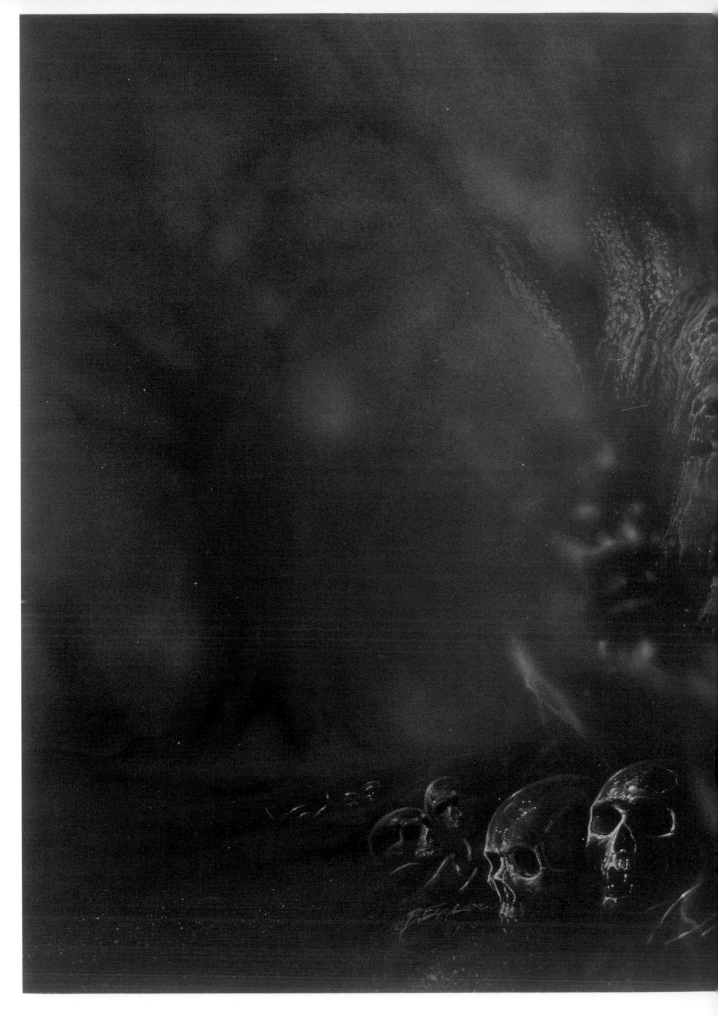

that he had multiple sclerosis and could only be persuaded otherwise by a scan which showed a perfectly healthy brain. Upon which he immediately became fascinated by the magnetic resonance imaging process that was able to provide such wonderful reassurance.

More directly, painting a whole load of skulls tends to lead one's thoughts in a certain direction. Does Bob have any strong views about death? 'My fear of death breaks down into two parts. Firstly, the question of how I will die, which no-one can escape worrying about sometimes. And secondly, my main fear of whether I will have time to do everything I need to do with my life before it's over. Will I have painted everything and done everything I wanted? I have no strong feelings about the afterlife. I don't subscribe too much to the Judaeo-Christian icon. I feel more comfortable with the thought that some

◀ *Dreamthorpe 1988*
Acrylic
15 x 15 in (38 x 38 cm)
Book cover, Dark Harvest Books
Author Chet Williamson

'It was hard to come up with an image for this strange book in which a wood comes to creepy life. I love painting trees and enjoyed playing around with the textures on this one, as well as the ghostly images of the skulls at the bottom.'

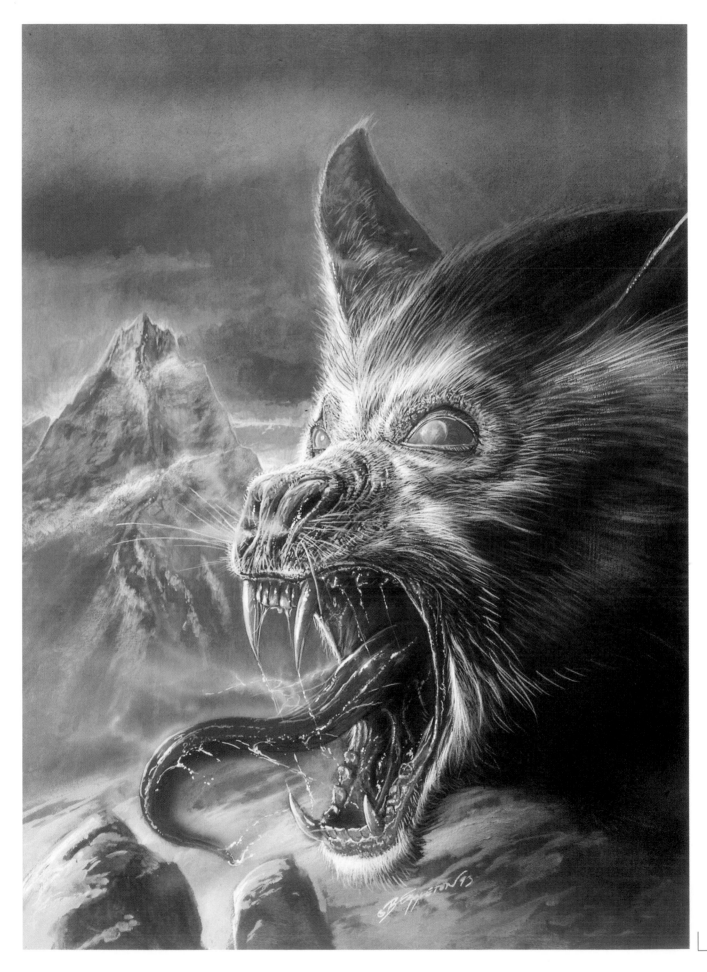

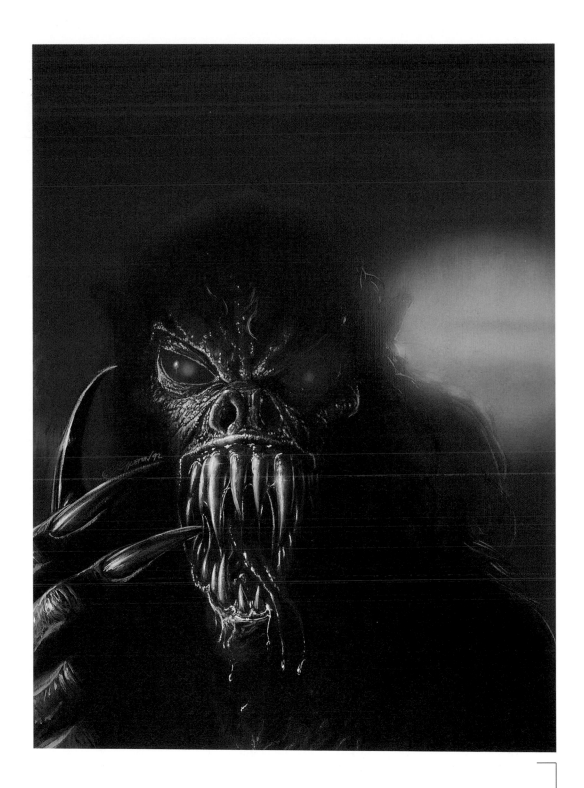

◀ *Werebeast 1993*
Acrylic
15 x 10 in (38 x 25 cm)
Cover, Necroscope: The Comic
Book *No. 6. Malibu Comics*

'I really tried to capture a lot of
action in this portrait of a werewolf.
The aim was to contrast the
complexity of the beast with the
simplicity of the background.'

▲ *Bloodthirst 1993*
Acrylic. 10 x 15 in (25 x 38 cm)
From Necroscope: The Comic
Book *No. 5. Malibu Comics*

'In comic books you're allowed to do
something a little more graphic than
you can on regular paperbacks. The wet,
gooey stuff was sheer joy to paint.'

kind of ascension takes place. But it's anybody's guess where you go. The sad part of religion is that I don't really believe they are talking the word of God. Religion was created by man. If there was a Supreme Being he'd be saying, "Oh no, you've got it all wrong. For a start I never meant for the Jews not to eat pork." A single example of why I find religion frightening is that only recently has the Catholic Church apologized to Galileo for getting it wrong about the solar system and giving him such a hard time.

'There may be a lot of religions that are non-fanatical, but the only type I could believe in would be something like Zen. There are aspects of religion that attract me, though. Like that famous Hindu sculpture of Shiva doing the dance of cosmic bliss, the god of destruction doing the dance of creation. Some scientist pointed out that it was essentially an image of the Big Bang theory of destruction and creation. I often wonder if the second the universe begins to shrink, the laws of causality will be reversed.

'And I love old churches. In Trowbridge, England, I visited a wonderful church dating from AD 800. I can overload on ancient architecture like that. I feel it through my hands. A relative once gave me a stone they picked up on holiday in Malta. I had to fling it out of my hands it felt so bad. It turned out to be from an old altar almost certainly used for blood sacrifices, human blood.'

Crucified Vampire 1993 ▶
Acrylic
13 x 19 in (36 x 48 cm)
Unpublished

'This began as just a sketch but after lightening it up I realized how finished it was, although a lot looser than usual. However, to be honest, it really shocked me how dark I can get.'

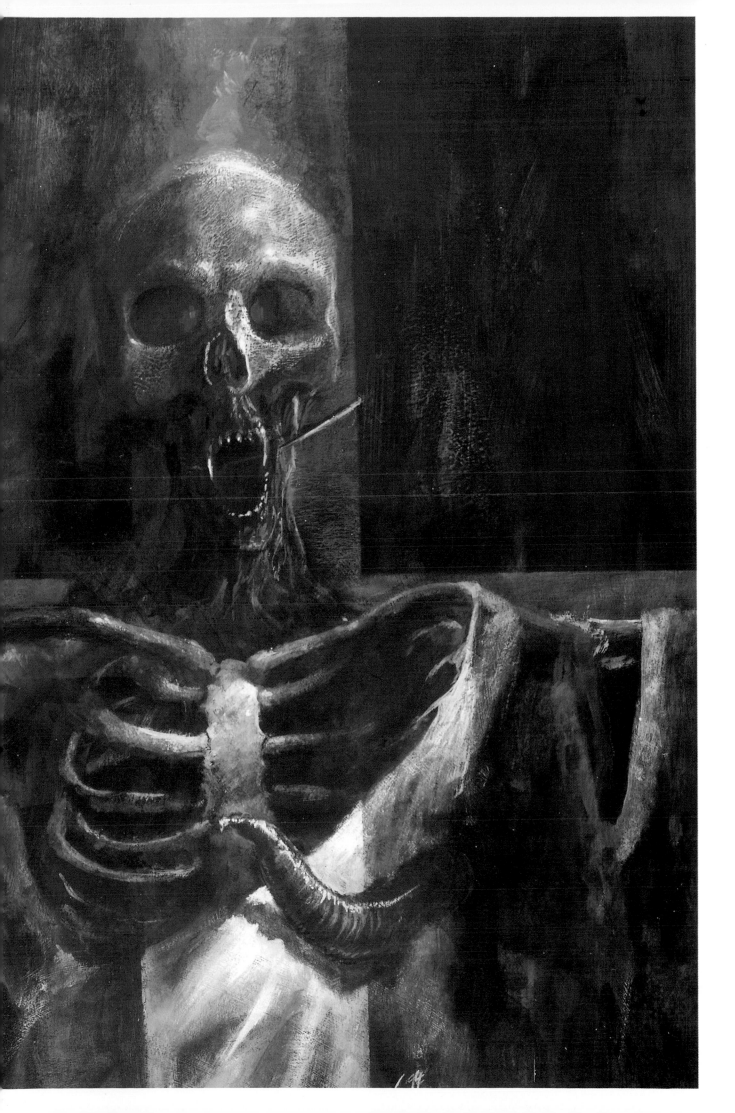

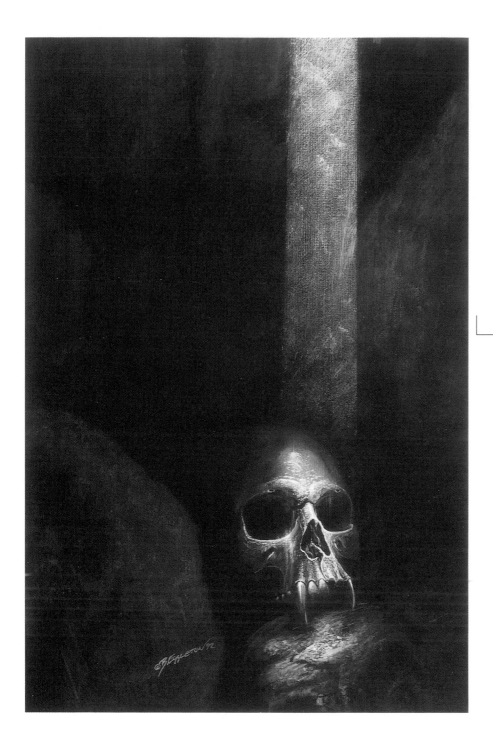

◄ *Dead and Buried?* 1993
Acrylic
11 x 14 in (28 x 36 cm)
Necroscope: The Comic
Book *No. 3. Malibu Comics.*

'They say you can do your best work
under a lot of pressure. I think I believe
whoever "they" are. This small piece,
done in under three hours, turned out
in displays to be one of my most
complimented. I used a very textured
board and all handbrushing.'

Anything Bob would like to add while on the
subject of the Dark Side? 'Well, on a personal
level, I do tend to have these really intense
mood swings. People wonder why I do such a
range of painting, I go from a real high to the
depths of hell sometimes. Occasionally I've
wondered if I should do something about it.

Cthulhu Awakens ►
Acrylic
11 x 14 in (28 x 36 cm)
Cover, Weird Tales *magazine*

Being able to do just about anything he
chose for this cover, Bob went for a
portrait of Cthulhu, the oldest of H.P.
Lovecraft's many demons, arising from
his pit. He found it a joy to paint and
it won him a fair bit of notoriety
among Lovecraft enthusiasts.

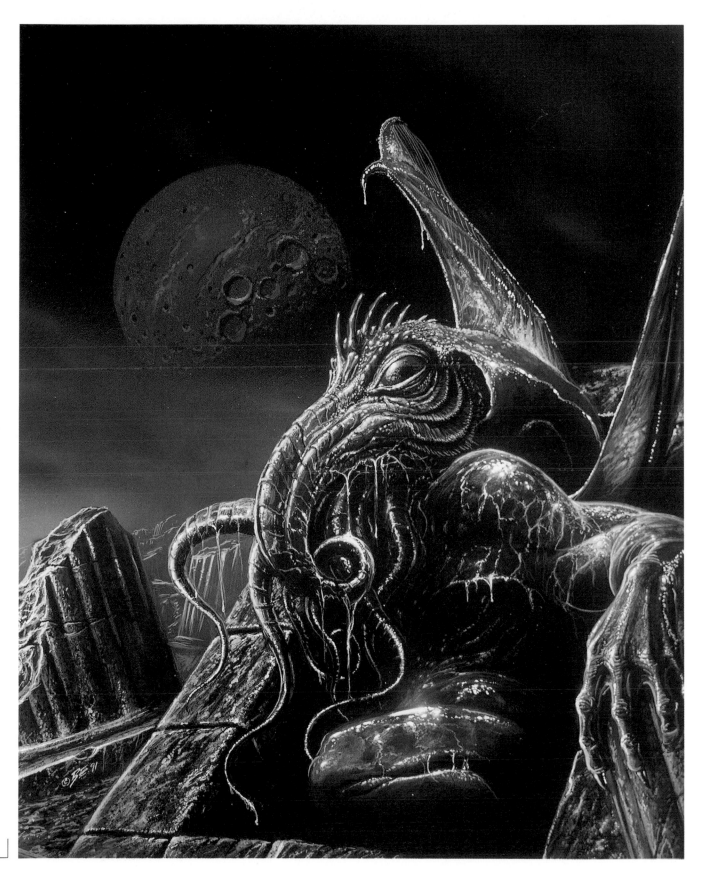

I've even consulted a number of friends, but they've said, and I've come to feel, that it's part of me. It's part of being an artist. Sometimes it's between the two swings that the most exciting ideas come. If you start interfering, who knows if they still will? I'm doomed to be an approval seeker, because that's what being an artist often comes down to. In a way

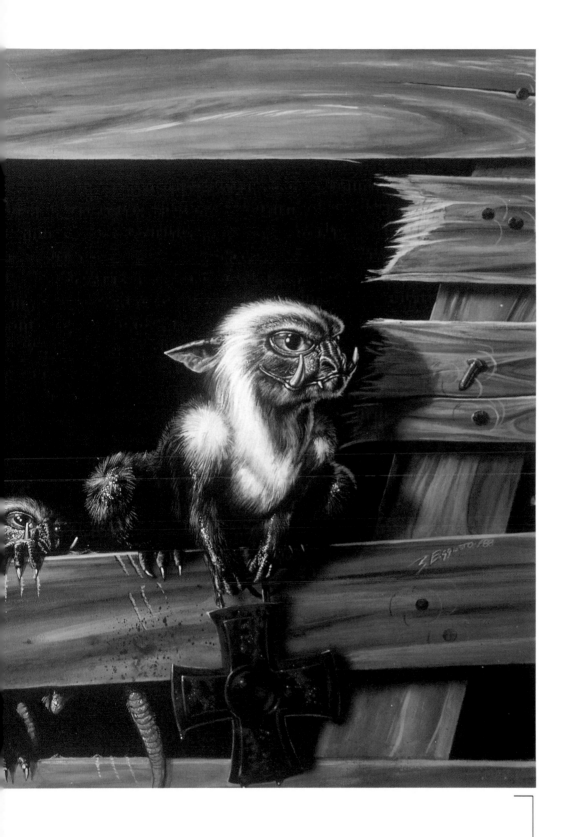

▲ *Crucifax Autumn 1988*
Acrylic. 30 x 20 in (76 x 51 cm)
Book cover, Dark Harvest Books
Author Ray Garton

'For a brutal story involving a demon-persona
who uses these furry critters to do his dirty
work. Many people seeing this painting have
nicknamed them the chihuahuas from Hell.'

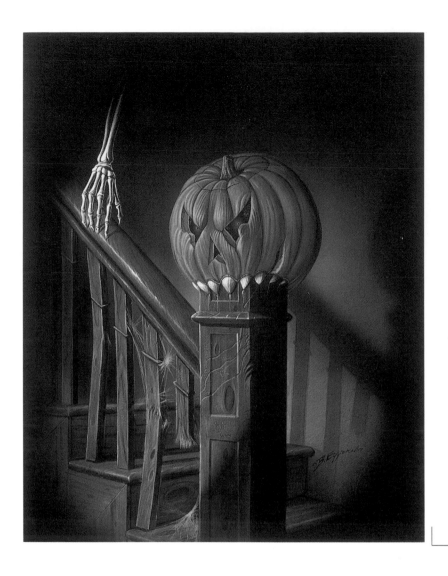

◀ *The Manse 1987*
Acrylic
20 x 30 in (51 x 76 cm)
Book cover, Dark Harvest Books
Author Lisa Cantrell

'This was my first ever horror paperback
cover for my friend Lisa Cantrell. I came
up with many ideas to begin with that
didn't work, and this is what taught me
how to produce a simple image for a
book cover. I came up with the concept
on a napkin in a restaurant while eating,
you guessed it, pumpkin pie!'

this kind of work is done for yourself but
ultimately you're seeking to please an audience.
I often take criticism badly, as a criticism of
myself rather than my work. But when work
goes well, I'm usually on a high, and there's
nothing else I would rather be doing.'

 Has he any idea where it is all leading?
'Not really. If I have a motto it's probably
that I go in search of a perfection I shall
probably never find.'

Mister Death 1993 ▶
Acrylic & Coloured Pencil
14 x 17 in (36 x 43 cm)
Interior illustration,
Science Fiction Age *magazine*

'Another really fun technique experiment
using no airbrush. I'd always wanted to do
a picture of the Grim Reaper and here got
my chance. I really enjoyed doing the folds
in his robes, as well as the image of the
souls drifting away from the scythe. Since
he stands at the end of everything else, he
seems the right guy to end this book.'

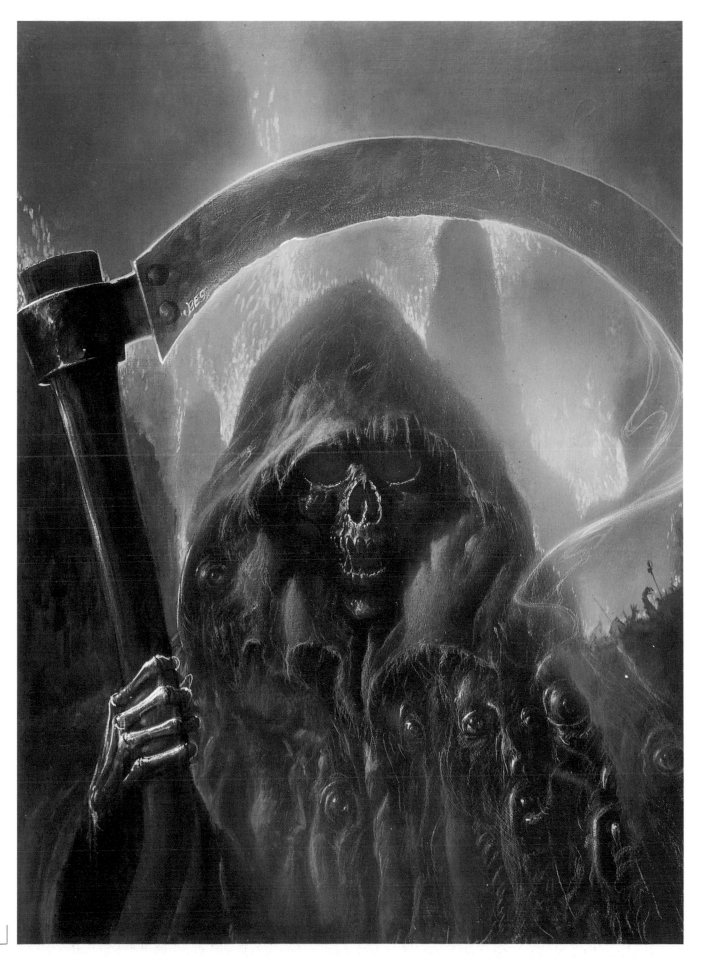

Acknowledgments

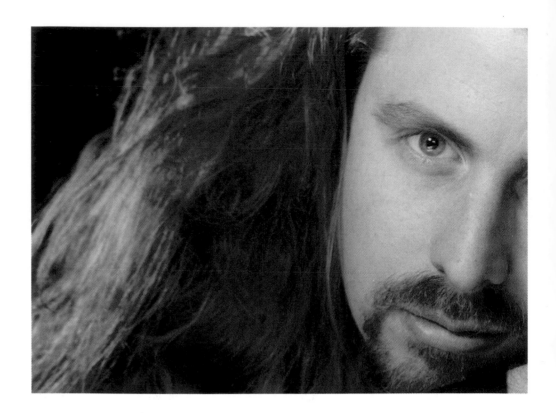

I'd like to thank the following people and organizations without whom this book would have been impossible:

Greg Benford for the prose and inspiration; Terri Czeczko for the commentary and for being one of the nicest earthlings to work with; Nigel Suckling for the interview and keen observations; Hubert Schaafsma for saying 'let's do it'; Karen Monaghan for introducing me to Paper Tiger (and for being a sweetheart anyway); John Strange for the easiest cover conference ever; Pippa Rubinstein for the great lunch; Fiona Courtenay-Thompson for 'lighting a candle under me' and everyone at Dragon's World. Also, to all the friends and fans who appreciate what I do and lift my soul when needed. To Abar Colour Labs and Slidemakers Inc — Jim Hansen in particular — for all the 'trannies'; British Airways for getting me there; and Fed Ex for getting stuff there. To all my artist friends and peers — you know who you are — all of you make all of us great.